LISTENING TO DESIGN

Listening to Design

A Guide to the Creative Process

Andrew Levitt

REAKTION BOOKS

Dedicated to the memory of my parents

Published by REAKTION BOOKS LTD
Unit 32, Waterside
44–48 Wharf Road
London N1 7UX, UK

www.reaktionbooks.co.uk

First published 2018
Copyright © Andrew Levitt 2018

Printed and bound in Great Britain
by TJ International, Padstow, Cornwall

A catalogue record for this book is available from the British Library

ISBN 978 1 78023 912 5

Contents

Introduction

I TEACH DESIGN in a school of architecture. On a typical day you will find me in a busy studio going from desk to desk meeting with young designers. One moment I may be listening to the boundless enthusiasm of a student who has broken through to some new awareness about a project. At the next desk, a student may be on the verge of tears. Overcome by self-doubt, these students feel burdened by having to develop a project they no longer love. These encounters are called 'desk crits', and they are the crucible of design education. Part classroom, part therapeutic exchange, no two desk crits are ever the same. They may last a few minutes or run for close to an hour. To become accomplished designers, desk crits are crucial and over the years I came to understand that we have as much to learn from our talents as our emotional upheavals.

Architecture did not introduce me to the profound value of listening. I began to learn about listening while training to become a psychotherapist. After ten years of working as a counsellor, however, I returned to the design studio and

immediately experienced the way listening attunes and guides the creative experience. Whether developing work with a team of colleagues or listening inwardly to one's own voice, the ability to be sincerely and genuinely receptive is an empowering agent for new ideas. Nothing is as mobile, direct or beneficial to problem solving as simply listening.

Listening to Design is meant for those who are passionate about design and those that care about creativity. It traces a path through an often chaotic and fragile process, from the first whispers of an idea through to a final project. No discussion about design would be complete without venturing into the emotional turmoil of getting stuck, self-doubt and even failure. It is never easy to accept that difficulties have always had an important message to deliver about our relationship to the creative process. Again and again I have seen that we are sure to experience challenges when our work needs to go deeper and grow more meaningful.

Listening to Design relates stories, lessons and ideas from the design crit as well as my own design education. It reveals the rich and complex way listening can empower creativity and bring unexpected inspiration to someone struggling with the most difficult of problems. In every school today there is a

danger of learning to design but failing to learn from design. This book offers practical advice on how designers can connect with their creative instincts and trust their imaginations. This is the wisdom of design The key to mobilizing a creative life rests on learning how to listen.

1

Design as Therapy

I WAS STARING at the man in front of me as we stood queuing to receive boarding passes for our flight. He had a shaved head and wore a grey robe tied at the waist with a thick cotton belt. I assumed that he was a Zen monk. When I looked down I was struck by the package on the floor beside him. It was about the size of a small under-the-counter fridge, but the way it was wrapped was remarkable. The outermost layer was a dark-green plastic, perhaps made from rubbish bags, but the way it was wrapped with duct tape and thick twine was sublime. All the edges of the parcel had a constant half-inch radius, which gave the shape its soft appearance, like a big gumdrop. The bold pattern of duct tape reminded me of calligraphy and the heavy-duty twine delicately traced a secondary pattern suggesting the calculations you might guess were involved in carrying such a load. The whole thing managed to look completely relaxed and extremely strong at the same time. The handle was a neatly formed cat's cradle of twine lashed together to form a comfortable grip. The sharp lines of duct tape were perfectly complemented by the delicate twine, creating an elegant and satisfying ensemble.

We were in a large airport terminal and much as I tried to look away, my eyes kept returning to the parcel. I finally gave up and just let my gaze rest on its economy and perfect equanimity. How long had it taken to complete the wrapping? It was obviously the work of a skilled craftsman. I could not tell if it had been fabricated at the last moment or carefully planned. Did the owner have help making it? Was the design the result of great effort or no effort at all? Just as I was thinking of asking the passenger

if I could try picking it up, the woman at the counter signalled to him to step forward. He picked up his parcel and together they moved to the counter. A moment later the monk neatly pulled his travel documents from his shoulder bag and when the agent asked if he would be checking any bags, he placed his handsome cargo onto the scale. The agent leaned forward to see what was there and then asked, 'Will you be checking just the one garbage bag?' The monk nodded. I watched as she hooked a baggage label through the perfectly crafted handle and lifted his belongings onto the conveyor belt, where they sat for a moment before being swallowed and disappearing through a rubber door.

To the designer the whole world is crackling and breathing with design. It may be entertaining or useful, humble or pretentious. It may be lasting or transient, but for the most part, designers have no choice but to watch the world absorb yet ignore their work. To the designer, an alarm clock is as honed and considered as an opera house. An architect I know lavished years of care and concern on designing the perfect bakery. Both the bread and the client were wonderful, but the location was wrong and the bakery closed shortly after opening. All of its beautifully made, bespoke fixtures were thrown in a bin and a discount lingerie shop quickly moved into the space and flourished. I agree with people who say that design can influence a person's mood. Of course a smile or harsh word can do the same. I believe that we design for the same reason that we become singers or mathematicians: love. We are called to it. We have no choice. The inexperienced singer thinks she is the reason that the audience is moved, but the wise singer knows that she is just a vehicle for a greater power that flows through her. That moving energy is the transformative agent. When a singer is moved, so, too, is her audience. The same can happen through the act of design.

WHEN I GRADUATED from architecture school in London
I felt elated and exhausted. I had been working non-stop for
five incredible years. I had given every ounce of my energy
to completing my studies and when I crossed the finish line
I was totally exhausted. Over the last two years of the course
I had found my way into meditation and had done several
ten-day Buddhist retreats, where I had felt profoundly happy
and completely at home. I decided that I wanted to spend the
next few years working part-time as an architect so I could
focus on studying Buddhist meditation.

Living in London and studying architecture had taught me
about the built world, and Buddhist meditation had pointed
me to the value of the inner world, but I had no idea how
to bring these two worlds together. I became increasingly
frustrated by this impasse during my fifteen years working as
an architect, so I decided to go back to university to study urban
design. I wanted to somehow bring my experiences into a single
stream. I was in the middle of researching postgraduate courses
when a conversation with an old friend suddenly highlighted
another possibility. Why not study psychology? Over the last
ten years I had been increasingly drawn to that field and had
been attending many kinds of classes, workshops and retreats,
where I had tried everything from Holotropic Breathwork to
yoga, Reiki and dreamwork.

I became convinced that this was the leap I was looking for.
I was drawn to a school in Philadelphia that distinguished its
programme from others by allowing students who had no
undergraduate training in psychology to do a probationary term.
If I scored high-enough marks in the first semester, I would be
allowed to pursue a master's degree in counselling psychology.
I went for the interview on the campus – which had been founded
by the Sisters of St Joseph – that reminded me of Montreal's

beautiful convents. Buoyed in part by the architectural quality of the place and in part by my lack of other options, I packed everything up and moved to Philadelphia.

When the course began I settled into a small, stone residential building and pronounced myself ready. The first psychopathology class, however, was a shock. I did not understand a word of the lecture. My lack of undergraduate psychology courses was going to be a huge problem. Psychology has a particular and esoteric language that is just as specific to it as anything I had learned in architecture. My colleagues, some of whom had come from backgrounds such as law or political science or veterinary medicine, had no problem because they had all studied undergraduate psychology. My sense of accomplishment after persuading the school that teaching architecture and attending meditation retreats and workshops would make my transition simple seemed pitiful. I was in trouble. On my first day I ran out at lunchtime to buy a dictionary of psychology so I could try to keep up with the new terminology. The amount of reading expected of me was formidable and after four weeks I was in a hole so deep that I would not be able to catch up until the term was over. Sitting in the back row of the class I began to take stock. I could take notes, but I was not really sure what I was taking notes about. I read for hours every night, but comprehending even the most basic concepts was proving elusive. I began to wonder if perhaps I had bitten off more then I could chew.

Then, in my darkest hour, sitting at the back of the psychopathology class, I had a eureka moment. I began to draw architectural diagrams that explained what the professors were saying. I had always liked to draw and knew I understood best what I could see. Suddenly obscure theories about the psyche, the dynamic between inside and outside, ego and unconscious, classifications of differential diagnosis, became something I could visualize and understand.

My quick sketches of buildings converted the once opaque psychological world into architectural drawings. The familiar clarity of parti diagrams that I used to show the concept of an architectural design with arrows pointing to sections, elevations and plans allowed me to feel at home in the world of psychology.

For the first time I began to understand what I was studying. I joyfully drew what I heard. The architectural diagram became my best friend. Psychopathology lectures were still a challenge, but when they were translated into architectural language, I began to comprehend the enigmatic language of psychology. I diagnosed case studies as I would buildings. Glass facades helped me to understand congruence. Transference turned into transportation studies. Psychological transparency reminded me of essays by the architectural historian and theoretician Colin Rowe. I began to get a grip on the world of psychology and immediately realized what I found so exciting and profound about architecture: it was powerful because it was both physical and metaphysical. It existed as a built structure and an inner world, and psychology was both its perfect counterpoint and soulful twin. The concepts of inside and outside are related to both disciplines, and the congruence or dissonance between outside and inside is an important working premise for both professions. Context, narrative, mood, body and language are common to both. Comfort, presence and shadow are heard in both architectural and psychological case studies. Armed with dictionaries, textbooks and my faith in the magical power of architectural drawings, I passed the first semester.

Architecture and psychology have always been important places of learning for me, but their relationship to one another became clear when I began to teach in the design studio. Here I found the worlds of architecture and psychology to be overlapping and inseparable.

It turns out there is no formal training for becoming a teacher in a school of architecture – no special courses to take or exams to write. Some colleagues run architectural offices in conjunction with teaching, while others have more academically oriented interests. I never really had a long-term plan, and my journey to becoming a teacher in an architecture school has rested on a series of unlikely decisions. After I received a degree from the Architectural Association in London, I decided to immerse myself in the study of Buddhism. When not working in architecture offices, I took extended sabbaticals to travel, study and meditate. After completing my psychology degree I settled down and began working as a psychotherapist. Finally, as so often happens when we take a journey, I found myself needing to return to where I started and began teaching in the design studio. Life's twists and turns can seem disconnected and without purpose, but in the end I feel fortunate to have found my way back to doing what I love. Every design is a journey into the unknown and calls for equal measures of creativity and compassion. My own experiences tell me that good things happen when you stay true to yourself.

When I meet with students, I am interested in discovering one thing: what do they want to create? I am always listening to hear what moves them. If I have a philosophy of education, it is that to educate one must first discover where a student's desire and enthusiasm is located, so that it can be supported, strengthened and allowed to flourish. I want students to learn to trust their creative instincts so that they genuinely acquire the experience necessary to withstand the challenges of life and the design studio. Once students discover the power of their architectural instincts, the process of educating this creative drive flows easily. This may sound simple, because it is simple. Students bring a passion to their beliefs and this

effort and determination is a remarkable and precious resource in any design studio.

A friend told me about a group of architecture students who, after an evening of passionate debate in the design studio, left Montreal at midnight and drove to see a Louis Kahn building in New Hampshire. They arrived at dawn, but it turned out the building they were hoping to see wasn't finished. In fact it was not yet out of the ground. When they reached the fence surrounding the construction site they found themselves peering into a deep excavation in the earth and were transfixed by the building's perfect concrete foundations illuminated by the rising sun. They stood there speechless and in awe as though they had travelled to the Holy Land.

I have never advocated that anyone follow a particular style of architecture or design process. I really have no set rules about how to teach design because I have witnessed remarkable designs spring from multiple interests and combinations of approaches, many of which I could never have predicted. I am convinced that everyone has their own inspirations and challenges and therefore their own ways of being creative.

The most important thing about the architecture studio is that it is a safe place where the interests and enthusiasm of students can be nurtured. I do everything in my power to create and maintain this atmosphere, and I would consider anything less a failure. The result is always an opening of the great door of courage, learning and hope. When the design studio is filled with positive energy, it naturally runs itself. If given a choice, I would always rather students develop a deep connection to their own creative journey than try to impress or please another person.

W hat does a desk crit have in common with a therapy session, one that might deal with serious emotional problems that often have been building for years? It seems, at first glance, that the answer is nothing at all, yet I have experienced many desk crits that were as charged as any therapy session, with a student in tears from feeling overwhelmed by multiple deadlines, who has not been sleeping well and who is suffering through a terrifying creative block. The anxieties, frustrations and desires that we experience during the creative process are as real and tangible as any of the more obvious formal, cultural and technology-based issues that are universally accepted parts of the design process.

Even if the design process has gone reasonably well, it is important to acknowledge that every time we create something we form a deep and sometimes stubborn attachment to our work. Its fate inevitably becomes our fate. A creative setback can undermine our mood and shake us to our foundations. Consciously or unconsciously, we relate to our creations the way a young parent watches their child. Knowing how to stay related to what feels right creatively while being open to making changes is one of the most difficult lessons of design. Helping a student connect to his or her passion and awaken their sense of creative flow, can untie long-standing patterns of negative thinking, self-doubt and self-judgement, and can be very healing. Emotional blocks usually underpin creative frustrations. Many students are motivated by a genuine desire to bring greater beauty, social justice and amenity to the world. These aspirations underpin their entire approach to design. In this way their aspirations resemble those of a therapist; however, instead of healing an individual through a therapeutic encounter they bring healing to the built world though the act of design. This is an important way in which students learn to wrestle with their place in the world.

Today the idea and practice of therapy has moved well beyond the principles of psychology's founders. It is easy to find a therapist

dedicated to helping you promote wellness for every part of your mind and body. Movement-based therapies, art therapies, dream therapies, sports psychology and life coaching have added an ever-widening array of support to more traditional talk therapies. Psychology, like architecture, is a rhizome invisibly influencing everything it touches. So perhaps it would not be too much of a stretch to say that in the life of an architecture student, the desk crit, which is a special kind of interview with a focus on design, has the potential to be a therapeutic event that can only be enhanced by psychology.

A building can be photographed, an ego cannot. Yet there are buildings in every city that appear to be nothing more than the work of an egomaniacal developer, politician or architect. These very recognizable projects have no relationship to the conditions around them. They demand attention without making any contribution to urban life. They take far more than they give. A basic education about the characteristics of a healthy ego could help planners, designers and organizations recognize the difference between someone who is full of themself and someone with a more developed personality that is centred in themself. Every desk crit is at its core relational, as teachers try to find out more about a student's project and students try to find out more about design. Sitting with a student and listening to him declare his intentions for a more soulful world is something that has to be taken seriously. While some may doubt this, most designers try to use design to positively influence and enliven the well-being of the people who use their buildings, landscapes and artefacts. The ambition of architects to uplift and enrich the lives of those who enter or hold their designs closely mirrors the ambition of therapists and others in the health-care field.

First Dress

Halfway through one student's final year of the architecture programme, I was beginning to think that my colleagues were right. The project we were marking wasn't great. After three months of work, many aspects of it still failed to add up. Like a brilliant trial lawyer or barrister, one of the professors analysed the project and expertly listed all of the incriminating evidence. Another colleague led the charge to a fail verdict, reminding us of the institution's high standards. She claimed that this student was obviously not working hard enough and therefore did not care about what he was producing. There was a growing consensus that the student should not be allowed to complete his final term. Only one question was left unasked: why was an obviously smart and creative student doing so little with his talent? We adjourned for the day without a final decision and I decided to go and talk with the student.

The next morning, I met Jackson at his desk in the studio. At first, he refused to talk, but I persisted, telling him that he was in danger of failing and I really needed to hear his story in order to help him. There were three months left in his final school year and I wanted to see if we could turn the situation around before he had to pack his bags and go home after five years of hard work. Reluctantly, he began to tell me his story. In a very quiet voice he admitted that he had never wanted to be an architect. His dream was to be a fashion designer but he had been terrified to tell his conservative parents. He knew that they would never approve of his desire to study fashion. Over the years he had managed to hide his feelings and became a reasonably successful student, but now, with just a few months to go, the pressure of graduating and facing an unwanted future was too much. Jackson just could not keep up the deception. He told me that he felt like a fraud and could not go on, that he

had no more to give and needed to be true to himself. He knew that it made no sense to quit now, but did not know how to finish the year. He loved textiles and the world of fashion and had no love at all for what he was doing. Moved by his honesty and suffering, we came up with an idea that he was willing to accept. He would complete his project as best he could by pretending that he was designing a textile rather then a large public park. He would try to fold into the design everything he loved about fashion. I talked to the other professors and convinced them to give Jackson a low probationary pass.

For the next three months, he worked diligently until he thought that he had done enough to pass. When the time came to assess his final grade, my colleagues were unsatisfied – they wanted more from him. They were unconvinced by what he had done. They wanted to know why someone so skilled was settling for a low pass. I defended his work and argued that he had done enough. I was somehow able to prevail, and Jackson received a passing mark, which meant no additional work was required of him. I was satisfied that the best interests of the student and the school had been served.

About a year later I received an email from Jackson asking if I would write him a letter of reference for fashion school. I was happy to do it and wrote about his courage, creativity and determination. Our connection went silent again for another few months and then another email arrived. The subject line said 'First dress', and when I opened the email I saw two images. The first was a beautifully tailored polka-dot dress on a mannequin. The second image showed Jackson wearing a dark hoody that covered his face so that only his eyes were visible. In the email he told me that he had just been accepted into fashion school. Staying true to yourself is much easier said than done. Your creative life is like a barometer of your connection to yourself.

Design work always moves us into unknown territories where we are confronted by new lessons in how to remain true to ourselves no matter what. This takes time. Remember that design is hard to do well. Even more difficult is learning to be patient with yourself. When you are doing something new it will require developing a new connection to yourself.

The desk crit may seem to be an unlikely place for therapy, but many architecture students speak openly about wanting their designs to affect the emotions and moods of their users. Some architects want to shift cultural behaviour, if not the behaviour of those individuals who visit their buildings. At some point the discussion of what produces great spaces often ends in the kind of discussion of humanist values that would be familiar to many therapists and healers. Designers embody objects, places and spaces with the same qualities that psychologists ascribe to people. If we want to affect the world through what we create it makes sense to begin by looking at ourselves rather than by testing our theories on innocent bystanders. In the twenty-first century we are realizing that design is inseparable from who we are. A building cannot escape its maker.

Ego

A successful designer needs to have a strong ego. This does not mean that you have to be full of yourself; it means that you need to be centred in yourself. By that I mean centred in your personal needs and desires. In psychology a strong ego is also called an adult ego. Its job is to get you what you want. A strong ego gives you the power to fulfil your personal needs and desires. All of this presupposes that you are willing to consciously tune in to yourself and get to know your personal needs and desires. Finding a strong creative narrative, or big idea, is the corresponding design step. How does a strong ego help during design development? This is where it gets interesting.

Design development requires balancing what to hold on to and what to release. This takes experience because a sense of balance and restraint is not often associated with the ego. But it could be argued that the training of a modern designer is the process of acquiring a strong ego capable of making creative decisions. The ego needs to be strong enough to really hold on to the big idea, but mature enough to be willing to let go of whatever is unhelpful. One of the mysterious and endearing qualities of the ego is that it needs to be absolutely unrelenting one moment and willing to let go and surrender the next. Both actions are necessary – either one on its own will cause problems. Achieving a flow state means being fully and pleasurably immersed in a task and allowing yourself to manage this tension creatively. Because consciousness changes things, the best approach involves being aware of what your ego is up to during the creative design process.

You need to ask yourself, for example, what do I need to let go of for this project to move forward? What am I too attached to? What will I not let go of no matter what? These are pivotal questions and the answers can propel a design process forward. I often find that when

I subtly refuse to let go of aspects of a project, this resistance builds until suddenly I feel ready to do so and a great vortex of changes begin to happen. When the dust settles I can see that a new, promising project has emerged from the old. The paradox of the ego is that its stubbornness pulls us forward, but these very gains may need to be sacrificed to take the next step. Letting go does not mean losing the strength of the ego. It means freeing ourselves of unproductive attachments to ideas, drawings and positions that the ego enjoyed creating. The ego, after consciously surrendering a position, is always reborn a little wiser, a little more humble and more resilient.

A strong ego brings a formidable kind of energy when we need to investigate creative hunches. It is really helpful in its ability to adhere to a process and to continuously examine a question. In a way the ego holds a space for exploration. It can be brave, like a hero willing to explore new and unknown worlds, and at the same time as steadfast and nurturing as a devoted mother who always believes in her child's ability to succeed. It can also be willing to abide by an unexpected intuition or insight and instantly make adjustments in service of the higher creative ideal. A strong ego is always willing to admit a mistake because it has learned the joy of learning new things. The ego grows more resilient, adaptable and capable every time it recovers from mistakes.

I ONCE STUDIED with a meditation teacher, a charismatic leader who built a large network of meditation centres around the world that were guided by ancient and ennobling principles. He had both strength and kindness, and in the time we were together I came to see that he really lived in the present moment. He was sometimes amusing, sometimes inspiring, and I never saw him manipulate events or people. He was the same with everyone he met. From a distance it seemed as though good things just came

to him. He truly seemed to ride the moment-to-moment waves of life with complete equanimity. One day, after a potentially complicated situation was transformed into a victory for all concerned, he quietly turned to me and said, 'You have to know when to lead and when to follow.' I think that sums up the life of a healthy ego and its role in the creative design process. Change is constant when we create. Designers have to learn to stay centred and use their egos to be attuned to these changes.

Some time later I had an experience that showed me how one person's lack of self-awareness can affect an entire room and one's ability to be a good teacher. Just before I was about to speak to a university audience about design, an older professor, who had been teaching at the university for many years, came up to me and introduced himself. He chatted with me about several of his colleagues, wondering if I knew them. I usually like to allow myself some quiet time before a presentation so that I can gather my thoughts, but he confidently continued to offer his opinions on a wide range of subjects. Only when my host began to introduce me to the audience did he go back to his seat. After my presentation, there was time for questions. Following a short pause, the professor began to speak. He was slow to start, but he quickly got fired up, explaining that technology was ruining the world, having negative effects on students and their learning styles. He talked about what was wrong with cities and what was wrong with the corporate world. As I listened, I realized that it was best not to interrupt him. He was critical of many things and repeatedly circled back to the theme of how technology was spoiling the world. As he continued his monologue, I decided to relax and just tuned into his emotional energy. As I did so, I realized that technology was not the problem; the real problem was his anger. The more I listened,

the more convinced I became. After he had been talking for close to ten minutes, I could see that the students in the audience had heard this rant many times before. They had tuned him out long ago. As the speaker, should I respond to his opinions about technology or to his unconscious anger? I was sure his anger was the real problem, but wasn't sure how to address it.

The tipping point came when I began to think about what it would be like to have this man as a teacher. I had to say something. Unconscious anger may be coated in sugar or spice, it may be cruel, clever or seductive, but at the end of the day when you are forced to listen to someone who is angry and narcissistic, your creative spirit can be broken. There had not really been any question in his rant, so I began by commenting, 'I hear you saying there are many things wrong with technology and our world, but I think the real problem isn't technology, it's anger.' The room went completely silent. A hundred students looked up from their phones and laptops. Then the professor blurted out, 'Well, you've seen me.' He admitted his anger and acknowledged that he probably needed to do more listening.

At that point my host asked the audience if there were any other questions; suddenly quite a few hands went up and a serious question-and-answer session began. Somehow the emotions of this angry professor had been controlling the room. When he acknowledged his anger, students felt it was safe to ask their questions. He remained silent and a rich and lively conversation flowed. Emotions are contagious. We catch them from one another much the way we catch a cold. You cannot protect yourself from every cold, but psychologically speaking, awareness offers the best immunity. Our unconscious often signals us in ways we cannot decipher. As the great psychologist Carl Jung wrote, 'Where love rules, there is no

will to power; and where power predominates, there love is lacking. The one is the shadow of the other.' Using teaching to gain power has no place in learning. This abuse always has grave consequences.

One of the things that makes design so challenging today is not the problems we face, whether they be social, economic, political or technological, but the number of choices we have. No one in the twenty-first century can say what a museum should look like. We are not even sure what the experience of visiting a museum should be like. Is a museum a building filled with antiquities to satisfy the curiosity of scholars or is it a place where a family can be entertained? Perhaps it is both. And what about those remarkable antiquities that museums rely on to boost their status and attendance? Some experts would say that those artefacts should be returned to the society that created them. Some say that if museums are not able to constantly increase their attendance they will lose their relevance. With everyone in disagreement about the role of the museum, it is unsurprising that every new museum appears to be a novel expression of what a museum should be. Until quite recently, these questions were not debated. A museum looked like a museum, and its atmosphere was fairly consistent across cultures. In the twentieth century, however, the consensus broke down, replaced with questions to be solved by directors, curators and architects. Designers alone do not decide what a museum is, but the decisions they make on behalf of an institution become its personality and express its priorities and character.

A designer wears many hats, but none are so lasting as the one that determines what the building 'says'. This has become a big part of what makes life so challenging and exciting for young designers. We live in a time where there are no agreements about what is

right or wrong aesthetically, and the range of what is technically possible seems to grow by the week. The centre of gravity of the creative act has shifted away from society and falls directly on the individual. Today a designer needs to answer questions that go far beyond what he or she would have had to deal with not so long ago. For these reasons I would argue that the great secret of design is to understand it as a special kind of desire. What do you want to say? What do you believe is important? What is your project to be about? Who will benefit from your design?

In architectural terms, every building is more than its programme. It is more than its materials and location and need to be structurally and environmentally sound. It needs a programme, material, structure and site, but none of these alone are the experience of the building. In the twenty-first century, every design decision has global implications. We are commenting on the past, the present and our hope for the future. How does the designer bring his or her voice into this? By answering one simple question: what is it I want to say? Design is an opportunity to say something about our world. The real reason it takes so long to become an architect is that we are tasked with acquiring a new imagination. An architectural imagination that can give voice to personal as well as altruistic ambitions. The entire design process stays in flux for as long as possible in a kind of creative version of natural selection, working through countless permutations in search of what feels right.

When young designers have trouble getting in touch with what they want to create I suggest that they connect with their heart's desire by asking themselves: what do I love? What do I care about? What causes me to feel fulfilled and enthusiastic? If you like motorcycles, go to a Ducati store and arrange a test drive. If you like a particular brand of shoes, go to a shoe store and try on a few pairs. Walk around in the shoes you love. Get familiar with the feeling of being at one with your heart's desire. Just follow through

with what moves you. Get as close as possible to the feeling of having your wish fulfilled.

Really knowing what it feels like to have your body and mind filled with joy is a major resource for a designer. The goal is not to own expensive motorcycles or shoes but to get to know at first hand the feeling of having your desires fulfilled. By learning to trust these feelings, we build a foundation of trust with our creative instincts. Over time, this strengthens our ability to navigate the complex decision-making that designers constantly face in following their desire to make the world a better place. When given the chance to reflect on what we truly want, most of us do not choose to take actions that harm the natural world or create places where people will suffer. When combined with the trust in our creative instincts, this simple wish for human and worldly betterment brings courage to the imagination.

A young student I had taught emailed me asking if we could talk. In his email he had mentioned that he had been feeling depressed, was having trouble concentrating on his work and was worried he would fail the term. He looked as if he was not eating or sleeping well. He told me that he had tried to meet with the counsellor but as the term was nearly over she was swamped with requests and he couldn't get an appointment to see her. The student looked completely dispirited as he spoke about his inability to work. I asked him if he had ever found himself feeling this way before and he said that he had under different circumstances: the end of a relationship, the stress of constant travel and relocating to a new city. Each time he had managed to find his footing, but for some reason this time felt different. This time he was feeling hopeless. I asked him what he liked to do when he wasn't busy with his school assignments. It turned out that he had travelled widely and told me about a wonderful steam bath and massage he had had in Finland. He then talked about the pleasures of jogging every day, which he used to do but had since stopped. Finally he spoke about his love of woodworking and all the things he had made, but said that he hadn't been in the woodworking shop in months. He finished speaking and looked down at his hands. I told him that I was really impressed by the many rich experiences he had enjoyed in his life and suggested that we build a plan that rested on these positives. 'What about getting a massage?' I suggested. He immediately perked up and told me that he would arrange a series of massages through student health services. Then he told me that since it was a beautiful day, he would go jogging after his desk crit. And finally he admitted that for some time he had wanted to make a wooden picture frame but had not done anything about it. He said he did not know why he wanted to make it and without a logical reason for making it the idea had

just disappeared. It had got to the point that he had so blocked his creative spirit from manifesting that it began to shut down and was no longer available to him. He had repeatedly talked himself out of making it because he did not know why he wanted to do it.

I told him about a small table I had recently made. No one asked for it to be made. No one in our family needed a table. There was no logical reason to make it other than the pleasure of doing it. I had the impulse and acted on it. 'Maybe you don't need a reason,' I said, 'maybe you just need to honour your desire.' He was a very skilled woodworker but a negative voice inside him had become a menacing bully that stopped him from acting on the things that inspired him. No wonder he looked so hungry. He had stopped loving himself. What he wanted was completely attainable and totally within his control. I noticed that he had begun to smile, that his voice was stronger and that he appeared to be looking forward to his next few steps. When I saw him a week later he told me that he had spent the weekend in the wood shop and had finished his picture frame and that his studio project was now going well. I encouraged the young man to do what inspired him and his creative drive returned. We had never even discussed his design. I find that when I accept students as they are, they naturally recover their energy and interests, feel empowered and can outgrow their problems.

Becoming conscious of our desires and creative instincts plays a role in everything we do. Without a willingness to honour our personal needs and desires the creative spark will die. As crucial as this is to the creative process, however, I have learned that the unconscious mind often has the final word in directing our comings and goings.

FOR SEVERAL MONTHS I had been looking forward to
attending a Buddhist meditation retreat, the third ten-day
retreat I had attended that year, and I couldn't wait for it to
begin. No sooner had I arrived and finished unpacking than
I developed an intense headache. Earlier retreats had brought
an unexpected sense of bliss. As soon as I sat down and began
to meditate, an exhilarating peace had overcome me. I had
fallen into a deep and effortless stillness of breathing silence.
I had felt so at home that it alarmed me. Could it be that
I was meant to follow the monastic life?

This time was different. I thought that I had probably
brought on my nasty headache by trying too hard to focus,
but I could not shift my attitude and became increasingly
frustrated and angry. By the second day I had reached my
boiling point and could not sit still. Unable to meditate or
investigate my anger, I decided to leave the meditation hall.
Without bowing as we had been taught to do, I marched out
of the hall into the cool autumn air. I was in a foul mood.
Turning a corner in the garden, I collided with the head abbot,
who had been standing alone in the sun. I have no idea why
he was there; in fact, I had never seen him outside of the
meditation hall. He stood motionless in his long ochre robes,
like a giant bird drying his feathers.

Although we were expected to stay silent during the retreat,
I immediately blurted out, 'I've got a terrible headache.' To my
surprise he broke into a big grin. His reaction made me feel
silly for getting caught up in trying to get rid of the headache.
I was obviously so attached to my desire to be a perfect medi-
tator that I had blocked my ability to sit quietly and breathe.
At the same time, his response also comforted me, because
standing next to him my news did not seem very important.
Without saying a word he extended one arm so his robes

formed a big protective shelter. He began to turn slowly and
I found myself turning with him until we both stood facing
a new direction and I saw a gap in the thick bushes. Before
I knew what was happening, we both stepped through the
opening and arrived in a clearing. I stood there for a moment,
blinking in the sunshine. Not a word had been spoken, yet
I felt that a great burden had been lifted and I slowly began
to walk back to the meditation hall.

When I sat down, my mind felt loose and easy and later that
morning I felt a clap of thunder explode inside me. I felt as
though a rock had shattered, leaving me with an inexpressible
joy. This bright, peaceful clarity stayed with me for weeks, and
by the end of the meditation session, whether walking or
washing dishes, waking up or going to sleep, I experienced
a constant, aching bliss.

At the end of the retreat I was eating in silence when a
monk told me that the abbot wished to speak with me. Over
tea he explained that he had been asked to teach in various
communities in Scotland and wondered if I would like to
accompany him. The first stop was Edinburgh, but cities such
as Glasgow, St Andrews and Dundee were also on the list.
I agreed and three weeks later we met at King's Cross Station
in London and boarded the train bound for Scotland. We
travelled to dozens of local Buddhist groups, where the abbot
gave teachings and I was his attendant. Every day was the
same. We woke up at four in the morning; I needed to use
an alarm, but the abbot was already awake when I opened my
eyes, sitting and quietly meditating. We would either go to the
home of a supporter, who fed us a meal, or I would make him
his one meal of the day, which had to be served before noon.
He often tried to rattle me with questions, such as asking me
whether I would be on schedule with the meal, or how to set

an alarm clock, which he asked while I was trying to prepare lunch or while I was cooking. He seemed to delight in causing me to lose my sense of centredness and become angry. It wasn't that difficult. Once he had me good and bothered, he would mirror my frustration. When he saw that this made me even more upset, he would leave me to figure everything out. In the afternoons and evenings, he taught meditation or gave a talk about Buddhism. This went on for two weeks. I felt like a peeled tomato. His unwaveringly cheerful and self-reliant mood was inspiring to everyone, but I was full of emotional turmoil. I grew a greater and greater resolve that if I made it back to London without going mad, I would never see or speak to him again.

I never saw him sleep and I really do not know if he did sleep; his energy and centredness seemed boundless. During the two weeks of walking, travelling by bus and train, and encountering countless social situations, I never saw him in a mental or emotional state that was not kind, energized and service-oriented. And whenever a situation became the least bit uncomfortable, he would effortlessly draw on his wonderful sense of humour to diffuse the tension. His equanimity only increased my moodiness. After two weeks of his gently pointing out my inability to be present, I was only interested in one thing: escape. I believed that I was travelling with a madman who was able to be good-natured, centred and relaxed with everyone he met, but who insisted on torturing me. On the train trip back to London, I don't remember saying a word. During the whole train ride, I was planning my escape. I could not understand what he was trying to teach me – all I knew was that I never wanted to see him again. We returned to the Buddhist temple in London and I remained there long enough to join in evening prayers, then left to stay with a

friend. As I prepared for bed that night, I realized that in my haste to leave I had left my backpack at the temple. I decided that I would take an obscure bus across the city at 4.30 a.m. so that I could get my bag without being seen. I set my alarm for four in the morning.

That early in the morning the city is silent; that day the birds were just waking up as the headlights of the approaching bus illuminated the road. The big diesel engine slowed down with a groan before chugging to a stop. I climbed into the brightly lit interior, said a quick 'good morning' to the driver, dropped my fare into the box and turned towards a seat at the back of the bus. Then, as the bus accelerated, I lifted my head and saw the big happy grin of the abbot. He was sitting on a seat at the very back of the bus as if it was his throne, looking as though he expected to see me. How could he have known I would be there? He and another monk sat with their begging bowls on their laps, radiating the relaxed joy that I so wanted to experience. The three of us were the only passengers on the bus. The abbot explained that he was on his way to visit a lay supporter who had invited him for morning alms. I sat down, confused yet happy to see him. I had done everything in my power to avoid seeing him again, but the wisdom of the psyche was having none of it. What I thought was over was just beginning. That moment of synchronicity on a pre-dawn bus in North West London made an unforgettable impression on me and marked the beginning of a journey that shows no signs of ending.

Often what we need the most cannot be designed or planned. It is the unexpected and unexplained gifts that come not from the ego but from the wellspring of acceptance. Jung wrote that the ego has sovereignty over all of which it is conscious. This statement implies that it is the unconscious, which is outside of our ego's control, that can bring new possibilities. Our job is to be willing to accept them.

Like many designers, architects want their designs to influence the emotions or behaviours of people and sometimes even societies. Although changes in mood or behaviour as a result of design are very difficult to accurately measure and are therefore rarely scientifically studied, the ambition of architects to make the world a better place remains important. Before we attempt to change others, however, I think it is useful to examine what influences our own mood, looking inside ourselves as designers to answer questions such as: does my mood influence what I design? And if it does influence what I design, does that mean it can influence a building's occupants? Can my built intentions influence behaviour? To what degree does the mood of the cook influence the taste of the food? Many people fondly recall home-made meals with the implication that love and one's companions have an impact on the food. Is the same true for the designer? To what degree will the occupant of a building unconsciously experience the mood or intention of the designer? Do we, as designers, have to become more conscious of the fact that our states of mind could have a positive or negative influence on the end result? Could someone who does not really enjoy the company of people design a great public space? Can a mean-spirited person or bully design a beautiful place? If I am feeling depressed or filled with worry and anxiety it is likely that when I visit the most celebrated building in the world it might not seem to have much to offer. On the other hand, just as a kind word might

lift someone in the midst of a banal environment, so too might a building have the capacity to touch people. Everything has that potential. But how does architecture touch a person? How are emotional signals transmitted through material, time and space? The relationship between a designer's state of mind and the ability to be creative is not taught in architecture schools. What could be more helpful to a student trying to learn to be creative than to learn how to relate to creativity?

Four Functions

Carl Jung's discovery of the four functions of the psyche can be very useful in the design studio. Familiar to many as the Myers–Briggs personality test, Jung's premise is that we all have four ways of being in the world: thinking, feeling, sensing and intuiting. One of these will be dominant: it will be the typical mode of being or faculty that we are most likely to draw upon to solve a problem or face a challenge. According to Jung, two of the other functions support the dominant function and the fourth function will generally be undeveloped and remain dormant. The undeveloped function is often the one that causes us to get stuck because it is the one of which we have the least awareness. It is certainly the one that we must consciously develop over the course of our lives. The idea is that we strive to have access to all our functions so that we can have the greatest possible range of resources available for our life's journey. You can consciously try to develop it, but it happens quite naturally on its own.

Some students, perhaps the 'sensing' types, really benefit from making models and getting their hands into the creative process; when they do so, they often make swift progress. They understand the world through their sensing abilities and because of this can have a hard time when they try to rely on their intuition. They 'make sense' of reality by perceiving external and internal stimuli.

I once met with a postgraduate student who was having real difficulty deciding on his design thesis topic. He would set out in one direction and then double back and try something very different. He explored and analysed each idea, but none of them were convincing. By the time we met, he had already been in this state of indecision for several months. He tried hard to make a convincing argument for each approach, but they all sounded contrived. After a particularly futile meeting, he became angry

with himself and told me that he was going to the gym to work out. Over the previous few months I had noticed that his arms and shoulders were getting larger as his project floundered, and suddenly I realized that he was a 'sensing' type who been trying to gain traction by intellectualizing his ideas. What he really needed to do was involve his body, to think with his body. As he was leaving I suggested that he take a break from trying to figure things out mentally and just try to make a model of the kind of architecture he was after. With nothing to lose, he agreed. When I saw him the following week, he walked in with an armload of models made of all sorts of materials. It turns out that he had started making models as a way of thinking about architecture and had not been able to stop. He had been making models since we had last met. So intense was his newly discovered appetite for fabrication that when the school workshop closed in the evening he would take his models home and start working on them in his kitchen until late at night.

As he worked on several models at the same time, the narrative of his thesis became clear to him. He had not stopped thinking, but ever since he had started working with his hands, his thinking had become more useful. He had begun to draw on a very developed resource, his sensing function, and had found his way. It was a very similar process that led me to draw as a way of understanding the dynamics of the psyche. In his case, his best thinking was done from his body and through his senses. What followed was an intense and exciting period of crafting his thoughts by making models. He modelled and explored spaces the way a painter might work with colour, recording all of his experiments. He was by nature a sensing type and had discovered that his best way of thinking involved making things. After his euphoria subsided, he began working on a more nuanced series of models that looked at the relationships between materiality,

memory and space. He also began to study the work of other artists whom he felt were guided by making rather than thinking and he wrote about their various methodologies. I enjoyed observing the healing way his creative energy brought him deeper and deeper lessons about his innate approach to design. He was learning not only to design, but about himself by reflecting on the process of design. I was certain not only that he had gained hard-won knowledge, but that this knowledge would serve him well in the future. Whenever I see someone who is stuck, I want to hear about what they have been doing. Creative energy sent into the wrong medium will rarely support the creative process.

One year a student completed a very successful project that was startling in its originality. It was also remarkably different from the design solutions proposed by everyone else. This was very unusual because typically during a design exercise the complexity of integrating a building programme, site constraints and the demands of structure drive design options into a finite number of formal responses. This student's final project, however, was truly unique in that she had found a completely different way to resolve all of the issues of the project. It had the quality of a 'vision'. When I asked her where the idea had come from, she gave the perfect answer for an intuitive type: 'I don't know. It just came to me.' Her ability to successfully develop the design spoke to her talent and skill, but unlike a 'thinking' type, who might effortlessly produce a catalogue of sources and factors, an intuitive can get an idea 'out of the blue'. Universities naturally have a bias towards intellect, so designs that rely on thinking are often well represented. And while we all need to be able to think, we also need to be able to feel, to have fresh ideas and bring our bodies into the decision-making process; after all, our clients and collaborators and the users of design projects are also drawn from all four functions.

ONCE, WHEN MY car needed maintenance, I took it to
a friend who was a brilliant mechanic and had a garage
in a small shed on his property out in the country. After
we exchanged courtesies, he opened the hood and proceeded
to give me an accurate history of my car's reliability. It seemed
as if he had not checked a thing. When I asked him how he
knew so much about the car's history, he told me he always
relied on his sense of smell to initially diagnose a car. All four
functions are necessary and the ability to know your main
'function' will pay dividends when it comes to moving forward
creatively and learning from design work. The four functions
offer an impartial model for reflecting on getting to know our
self. They naturally ebb and flow over our lifetimes. Finding a
label that fits is far less important than honestly reflecting on
our strengths and weaknesses. By observing the way people
approach design, it becomes clear that there is no preferred
function and that no particular function has a monopoly on
creativity.

2

Listening and Receiving

SIX OF US were sitting in a circle in the dusty office that also
functioned as a meeting room, canteen and training centre.
As usual, the shades were pulled down. The place had not been
cleaned for weeks. It was early evening in the dead of winter
and we were talking quietly, waiting for our final training
class to start. After tonight we would be qualified to work as
volunteer crisis counsellors, answering phone calls from people
who had no one else to turn to.

The crisis centre was born out of a happy meeting between
public need and commercial self-interest. Before computer-
automated telephone systems, the one person you were sure
to find at all hours of the day was a telephone operator, usually
a woman. With the advent of computers and digital voice
technology, it has become nearly impossible to speak with
a human being, but in the early 1980s when you called the
phone company you could still find a human voice on the
other end of the line.

Since some people have no one to call or simply don't
know whom to call, they often dialled the operator for help.
Eventually the telephone company realized that it would be far
more efficient to fund a special telephone crisis-centre helpline
than to have their operators overwhelmed with calls that they
were not trained or paid to answer. That is how the crisis centre
came to be listed on the front page of our local phone book,
right under the number for directory assistance. When the
phone company offered to fund the crisis call centre, the office
finally got some equipment and financial support. And, of

course, the telephone company could allow their operators to go
back to being operators. Like many other social service agencies,
the crisis centre was staffed by a small number of paid workers
and a larger number of people who, for reasons never discussed,
found it necessary to do more than have a nine-to-five job.

The mission of the centre was simple: to promise that
someone would be there to listen. A traumatized kid, a
confused parent, any lost soul could call to talk. Over my
time as a volunteer I came to learn that the place received
calls from both regulars who were unable to handle lonely
nights and people who were suddenly overwhelmed by their
inner demons. The people who called had the option of
remaining anonymous, and I am sure that for some this
made the decision to pick up a phone and call easier.

The six of us taking the course had been through five three-
hour training sessions that involved role-playing all kinds of
emergencies and difficult situations. We were given lessons
in the art of listening, but for the most acute situations we
were instructed to direct callers to the relevant social service
agency for more experienced help. We were a quiet group who
were mostly new to psychological work. I was fascinated by my
colleagues. If you looked around the circle, you could imagine
the barest outline of what might have happened in their lives
to bring them here. I often found that when I left our training
sessions and stepped outside, I felt lost and alone. The city
seemed completely indifferent to the fate of the people who
walked down her streets. Sometimes I would look at strangers
and wonder if in a few weeks I might be taking their calls.
I began to see the city as a place filled not only with buildings
but with all kinds of human stories.

On the final night of our training, everyone was feeling
light-hearted because we had nearly finished the course. The

evening also had some added emotional weight, because that
night we were going to role-play a suicide call. I had imagined
what it would be like to receive the kind of call in which the
line went silent because someone had killed him or herself
as I listened, but I hadn't dared raise this worry with anyone.
I sat in the circle, acting brave and feeling nervous. Jerry, our
instructor, patiently sketched out the setting: 'Okay, it's 1.30
a.m. and you are working the night shift. The phone rings.
You answer and you hear someone on the other end say, "I'm
standing on the subway platform and when the next train
enters the station I'm going to jump in front of it."' He paused
and looked around the room. We were all paying attention
to every detail of the scene. Until you have role-played a
traumatic psychological situation at close quarters, nothing
quite prepares you for the feelings that race through your
mind and body. We were trying to look anything but frozen,
but the dreaded situation that he portrayed was so possible
that none of us knew where to go for answers.

A very solemn and focused older woman who had obviously
been through her share of tragedy looked down at the floor.
A pale young woman with dark bags under her sad eyes stared
back at the instructor. A gaunt man with a beard who said very
little and resembled a priest seemed to be willing himself to sit
still and appear strong. A usually upbeat older man suddenly
looked depressed. My hands were sweating, but I, too, tried to
look calm. Jerry said, 'Now I'm going to go around the circle
and I would like each of you to give me your response to the
call.' Around we went, the first woman stumbling, asking
the suicidal caller for his name, asking him to talk about his
feelings, asking intelligent questions. Then she wondered aloud
to the group whether it was possible to trace the call or connect
to some other emergency agency. Did the caller have a minister

or friend, a parent or sibling to talk to? With each question, Jerry answered perfectly in character that the train was coming and the tension in our group would rise. We were all trying so hard to say the right thing, to find the magic formula that would disarm the situation. I was sitting there calculating in my head like mad – OK, late at night the trains aren't too frequent . . . we have a few minutes – as the trainer continued around the circle. We were all feeling powerless and desperate as Jerry easily deflected each response. He had turned into the suicidal caller, irritated, angry, firing back sharp answers to our useless responses. It was obvious that we had no idea what to say. Finally he came to me. I was the last person. Role-playing may sound harmless, but any sense of play had vanished; a very powerful drama had been created. I was terrified. My brain froze. Jerry patiently reset the scene and repeated the suicide call, 'I'm on the subway platform and when the next train comes into the station I really feel like I have to jump.' Out of nowhere I heard myself say, 'Thanks for calling. I'm really glad you called.' Jerry was silent for a heartbeat. My brain wouldn't focus. Then for the first time his voice softened. 'Yeah . . . I haven't been doing too well lately.' Relief swept through the room and a surge of normal breathing returned. A conversation began. After that evening I decided to always answer the crisis centre phone by saying, 'Thanks for calling.'

The act of listening is magical because it makes things happen without seeming to do anything. It offers up a space for becoming; is both a gift and a peaceful force that has the power to reveal whatever is missing or obscure. It is well-known by healers that someone who is suffering and doesn't feel well often feels better after being heard. You haven't given advice or tried to change anything, but have simply transformed the situation through the act of non-judgemental listening. To feel heard is to feel seen and appreciated for who you are. This very simple act is always empowering. At a desk crit a student who has been truly heard may talk through their project and suddenly understand the next step or have insights they couldn't otherwise imagine. A lazy person's guide to design would be built on the profoundly simple act of deep listening.

I ONCE ATTENDED a review of a student project in which one of the professors criticized the student for being 'too passive' in his approach. On the contrary, I felt he had been wonderfully receptive to the signals he had received from the site and the circumstances of the project. Everything had a very planted and clear quality that echoed my own experience of what happens when you listen. The student had a passion for design and his approach was not what the other professors were used to. It was based on receiving, and trusting that being receptive would be enough. His project emerged from treating the circumstances he encountered at the site as a creative gift. He was as open to the sense of place and its qualities as a mother might be to her child.

When I first learned to meditate, someone asked my teacher a question about what to do about feeling restless. He suggested that we gently say the word 'patience' to ourselves. This was helpful at first, but after a few hours it lost its effectiveness and I shifted to saying 'deeper patience'. I have learned that patience and non-judgement are the foundations for listening. Listening has many layers. Non-judgement does not mean censoring honest feedback. Listening also means embodying what it means to be receptive. And because creativity is not something we can get but is something we receive, listening can be a precious opportunity to experience the dynamics of creativity. We think of ourselves as creative but serious reflection points to creativity as a gift that we receive and do our best to nurture and cultivate and finally deliver.

Listening is not taught in school. It is either not considered important or it is not obvious how such a skill could ever be monetized unless you are training to become a therapist. Architecture, which has a long and storied history of celebrating 'function', has left out the very thing that makes everything function better: listening. I am not sure why it has been so ignored, but it is certainly true that it is not something that patriarchal systems are known for. In a culture where governments, schools and all manner of institutions have been designed for centuries with an eye to enhancing built environments, how might a designer who has been specifically trained to listen respond? Listening not only brings warmth and a sense of belonging, but quietly trains us to recognize and resonate with our inner creative voice. Listening helps us stay in the present moment and, with practice, expands our ability to be receptive. We may all want to solve problems brilliantly, but our ability to hear what the problem is can easily become lost and distorted by our desire to be successful. Issues such as sustainability that involve the integration of many factors and many points of view are going

to be more and more possible when the skills of deep listening are more widespread.

WHEN I WAS running a large studio, we had four teaching assistants (TAs) helping with the desk crits. Some professors believed that the TAs lacked the necessary experience to help with desk crits, but I thought that it was important that they learn about design by listening. I gave them an introduction to the desk crit, outlining our goals and intentions, and asked that they speak to me whenever they faced difficulties or had questions. I kept a close eye on them and could usually hear them having positive discussions with the students. Three of the four of the TAs had been very successful students, well-known for their original designs. I was happy to have their help and they very quickly made real contributions to the teaching team. As the term wound down, I noticed that the three really brilliant students were less in demand than their colleague. She didn't have much of a reputation as a designer yet always seemed to have a full complement of students wanting to speak to her. At the end of the term, I asked her why she thought so many students wanted to meet with her. She shrugged her shoulders and said, 'I really don't know. All I do is listen.' When you listen to others without judgement you are modelling how to receive. You are practising being open and receptive, the very things that nourish and invite the creative spirit.

For me, the desk crit is one of the greatest things ever invented. At first glance it seems simple. In my desk crit sessions, I visit a student at his or her desk to review the progress of the design project. We have a conversation that explores the status of the project and puts forward ideas, references, reflections and long- and short-term goals for its development. Our meeting can last for as little as ten minutes, but more typically the sessions are about thirty minutes. I have learned that a desk crit is an opportunity to reach deep into the living web of creative energy and explore the mysterious art and process of design. Inherent in every desk session is a conversation that examines what the craft of design can accomplish and what can block it from developing. It includes discussions of creative experiments, confessions, road blocks and breakthroughs. There may be drama, misfortune, tragedy, revelation, drawing and celebration. The depth of the exchange varies widely and is a product of the needs and experiences of both students and teachers. It is also an opportunity to carve out space for what is most important – students learning to find their voices and say something about the world through the act of design.

WHEN I WAS a student starting out at architecture school I refused to show my work to my teachers. I was very guarded and could not bear any criticism of my work. At the end of my first year, I received the following comment: 'Andrew has done little or no work this term, did not attend any tutorials, but his final project was good.' Just to set the record straight, I did a ton of work, but I was overly sensitive to criticism. If someone said that they didn't like my work, what I heard was they didn't like me. To this day I am always leery of sharing creative work until it has cooked for a while. What shifted things for me was a teacher who seemed to be genuinely curious about what I was trying to create.

I met David Greene in my second year. A founding member of Archigram, an avant-garde architectural group that came together in the 1960s in London, David was a natural teacher who was genuinely interested in what students were trying to create. His encouragement and observations were extremely helpful and wise. In a way, David was the first adult I had ever met who seemed to really enjoy what he was doing. He didn't seem to be at all worried about the things I expected adults to be worried about. He never seemed to be worried about following rules – in fact, he wasn't interested in making rules. He always insisted that we follow our own rules or at least be willing to question everything we were told. In every situation, he encouraged us to be faithful to our creative instincts. Having his support was a revelation. Until then, I thought that being an adult meant carrying some kind of burden because you had to. Suddenly, being an adult included following an intuition or expressing something you were uncertain about. David had a deep confidence in the creative spirit. He was kind and he didn't take himself too seriously. With his encouragement, I began to share my insights and enthusiasms and I grew less guarded and more experimental in my work. I credit his humility and sense of humour with creating a safe place for students to flourish.

As I described earlier, the process of creativity hinges on the ability to listen. We need to get into the habit of recognizing the authenticity of our inner voices. By hearing that voice without judgement, we can access all kinds of riches. All the ideas in the world won't help you if they fall on deaf ears. When we get an idea, there are so many ways of ignoring or sabotaging it. Staying true to the inner command is the holy moment of design. Listening is also the key to successful collaboration.

When a desk crit begins, my first question is always, 'How can I help?' Responses to that simple question can come in

many forms: a complaint, a drawing, a story of passion or a new inspiration. What I am trying to model is listening rather than being an educated or learned instructor who is focused on telling them what to do. Over the years I have heard as many positive as negative reflections about projects and processes. Sometimes students will confess that they are bored by what they are doing and we have to go back in time to find out when they were last happy with their work.

I want to hear the ambitions and intentions a student has for his or her work. I am listening for a great story. Often I am listening for something that is not yet drawn or formed enough to be considered an idea. Ambivalence, frustration and desire are just as important as certainty. I have no expectations of what any project 'should' be, nor do I believe for a moment that there is only one right way to design a project. A great story can be told from many different points of view, or through the eyes of a hero or an animal. I try to tune into the student's energy more than for any correct structure. At the start of a project, just as radar can identify a plane before it can be seen, I am listening for a formed or unformed idea that holds promise. If I do not understand the story or drawings, or if they are not aligned, I ask questions. At the early stages, my job is to identify the big idea so that it can form the basis of what is to come.

When I studied to become a psychotherapist, our professor used a video camera to capture our reactions while we were role-playing a therapy session. He wanted us to see how our faces and bodies reacted to what we heard. I thought that I was doing pretty well, but the film made it clear that only a very small part of me was listening; I was communicating dozens of messages that had nothing to do with listening and I could see that I was not really comfortable when I listened. I could observe that I was resisting the deeper connection that would come if I were able

to surrender to being present. Body language involuntarily but clearly signalled interest, excitement or boredom. That class was a lesson in tough love for all of us. I learned that whenever I did listen more fully, I experienced a psychological shift in which everything felt more positive and flow-based – that is, I quickly understood that when I stopped trying to make something happen, when I stopped thinking about my position and instead tuned into being more present, positive energy and co-creative solutions would naturally flow. Learning to trust this process is the work of a lifetime.

With deeper listening, the desire to change or judge the other person disappears and is replaced by a willingness to just be present. At first I worried that listening was not enough, but eventually I learned that listening itself is healing. When I listen to a student tell me his or her ideas, I get a sense of which ones are best. This isn't difficult; a good idea is physically exciting and the student will describe it with a genuine sense of energy. I feel it from them and sometimes I feel it for them. I am listening for the ideas that are the most fresh and have an inherent vitality that originates from an authentic place in the author. When I check to be sure that I have understood what a student means, I can see their relief. A perfect desk crit involves listening so completely that a student hears him- or herself and is naturally able to take the right next step forward.

Listening fully without any desire to judge or cause change can open the most stubbornly shut door. I use the image of an ear drawn in the heart to remind myself of what I am practising. I am not trying to gain anything, acquire anything, win an argument, prove a point or make a profit. Listening is the royal road to being present.

Often, if I hear a strong idea that is buried among many others, I take notes and draw what I am hearing. This way,

I can show it to the student so they can 'see' what I am hearing and contrast it with what they are thinking. Based on their feedback, we can see the gap between the two and identify what is missing. The disconnect between the words and the images offers a path to discovering why what is important is missing and not being communicated. The goal of the exercise is not to be critical but to draw out from the creative flux a moment that is capable of supporting growth and learning. A starting point. Encouragement can be much more important than criticism. Sometimes a blunt comment will liberate the blocked student, but it obviously depends on the student, so I try to arrive at each desk without an agenda. Even though this is generally impossible because I already know the skills, talents and characteristics of each student, it is still important to do my best to sit and listen without judgement. This builds trust and helps to create a safe environment where students are often more willing to creatively experiment and explore. Some students are gifted at describing their work, but that does not always mean their work is more thoughtful or better developed than someone else's project. There are other students who have a difficult time speaking and will sabotage their own work, but their ideas are clear and strong.

This is a co-creative experience, in which both participants are expected to model not only listening but reflection, literally at times drawing what the other is saying. In this mode, I often take notes, but they may be in the form of diagrams or drawings. Sometimes I just make a record of what was said to me and at the end of the desk crit return it to the student. It is a drawing of what I heard. My role at a desk crit is a cross between a poet and a cardiologist. I am dispassionately listening for a phrase or watching for a drawing that is genuinely alive. Does it sing? Does it feel alive? Does it ring true? If I hear a phrase or description

that has energy or insight I immediately write it down or make
a sketch. If what I am hearing does not match the drawing, or
if the drawing does not match what is being said, we have to
investigate the dissonance to find out what is happening. Is it
intentional? Is something dynamic leaking out from the idea?
Does something important lie in the gap between the two?

I am listening for an idea that has enough power to drive
the project forward. There are sometimes too many ideas and
none of them have the necessary energy. Sometimes the idea is
uttered without conviction. Body language may indicate that the
block is not one of architectural comprehension but of something
deeper. I find myself gently trying to build support so that the
idea can cross over from the unconscious to the conscious mind
when it is ready. Sometimes students have the ingredients but
not the recipe. Sometimes it is just the opposite. Listening means
receiving more than what is said. It requires that the listener
bring an awareness of the physical body to the experience. Is
the idea physically moving?

Sometimes after listening to a student describe a project,
I ask if he or she would permit me to make a rough version of
the project that I heard described. I am not trying to make a
beautiful drawing so much as give a clear picture of the project
as I understood it. I want students to see what they are capable
of if they follow through on their first thoughts. While I do not
want to rush the experience, I also do not want it prolonged.
My goal is to encourage the student to gain independence and
take the next step. Taking one step will lead to another. I always
try and make sure that the students have enough time to grow
through wrestling creatively with their work. If the students
can take the next step forward, then good things will happen.

Tom was talented and intense. He seldom smiled and at a desk crit could become quite prickly and uncommunicative. Even some of his classmates said that they felt a little frightened sitting beside him. No one knew what had happened in the past to affect him in this way. When my turn came to meet with him, I did not know what to expect. I listened as he took me through an explanation of his project, which was very thorough and meticulously drawn. He was proposing that a new urban community be built on a brownfield site that the city had ignored for years. The site had been left out of all the city's renewal plans and none of the improvements in the surrounding precincts had had a positive impact on the site. Tom had clear diagrams and detailed drawings that explained the complete history of the abandoned urban precinct and his timeline to revive it. As I listened to him, I sensed his frustration about discussing his work. He spoke quickly and seemed desperate to be heard. At times he did not even stop to take a breath between sentences. I listened and waited. When my turn came to speak I gave him my impressions of his project. I told him that I liked the fact that he seemed to be putting a lot of energy into getting to know the character of the abandoned place and was obviously very committed to doing something to renew its personality. I said that he seemed to be very aware of the harm caused by the city's rejection of this abandoned place. I sensed that Tom himself knew exactly what it felt like to be rejected and ignored. I liked the way his proposal rested on understanding the rejected place instead of rushing in to healing it. He instinctively knew that he had to accept it as it was and stop it being excluded. He was courageous for tackling something that had been ignored by everyone for so long, and I admired Tom's project for his belief that something good could come from the pain of rejection. Every time I used the word 'rejection', I could see Tom soften and relax, but as we talked, he began to look sad. He was listening and

talking more freely and more slowly. We had definitely connected through his design work and I asked him more questions about what it might be like for a part of the city to be so excluded from ordinary signs of affection for so long. He nodded every time he heard me mention the pain of rejection. His face grew softer and softer and gradually it became clear that he had somehow transformed his unconscious experience of being rejected into his urban renewal project. Together we discussed making the rejected and abandoned shadow of the city more conscious, looking at his project from as many different points of view as possible. Our conversation came to a conclusion after about forty minutes and later that day, a colleague told me that she was surprised to see how relaxed and peaceful this student looked. He had been heard.

Tom and I had several more conversations before the end of the term. His project had clearly become a way for him to heal from what was burning inside him. He had chosen a project that mirrored his wound, but to what degree he was conscious of this, I don't know. His final presentation was very good and over the course of the term he became more friendly and more settled. His project was widely praised not just for the skill of the drawings but for the unmistakable authenticity of the design. As Tom accepted himself he gained confidence; his connection to himself was stronger and this strength allowed him to share his work with his colleagues. Instead of being overwhelmed every time he spoke about his project he was able to be vulnerable and therefore more approachable. The qualities that were true for his work were true for him.

The main purpose of the desk crit is to help students learn to trust their creative spirit; a second purpose is to help students develop strong arguments for design; and the last purpose is for teachers to pass along relevant lessons about architecture, design and design development. All of these goals rest on the creation of a relationship that makes the learning experience possible.

Desk Crit Advice for Students

Begin by listening to what is going on within. Never abandon a creative impulse. Receive your creative idea as though it is the precious guest for whom you have always been waiting. Use the desk crit to test your ideas and design reflections. Practise making compelling arguments for your design. We need not only good design, but powerful narratives that support good design and honour its importance. Get feedback on all the experiments and tests you have conducted leading up to the desk crit. Before your desk crit, try to take a moment to reflect on what you believe is important for others to learn about your project. Have specific questions you want answered. A desk crit is a creative mix between a presentation and a dialogue.

Desk Crit Advice for Teachers

Begin by listening. Whatever positive things you hear and see, extend and amplify them. Balance honesty and empathy. Teachers need to be able to model receptivity and a positive relationship to the creative process. A good way to do this is to ask open-ended questions that initiate a dialogue rather than to deliver a monologue. Questions are critical because they can spark new avenues for insights or realizations. 'You shouldn't do that,' is very different from 'Tell me why you did that?' If this fails to move the dialogue forward,

I have often found that a question about the student's favourite music or film can quickly transfer the energy of the desk crit to a level that may have been left out of the design process. Though the question may seem ridiculous, it may actually serve the important goal of bringing the excitement and sometimes absurdity of the creative life into the process.

Understand that this is not a fair fight. You have the experience, expertise and authority to easily overwhelm a student. Learning to work with the power imbalance is part of learning to create a healthy relationship. Students are in a vulnerable position and if you abuse this power, you risk perpetuating the kinds of thoughts and relationships that make our world violent and unsustainable. The job of the teacher is to tune in to the student and build on the creative resonance of that experience. Teachers are not served by automatically thinking that what they have to say is more important than what a student has to say, even though a teacher may know more than the student. We all have our vulnerabilities and places of uncertainty. A teacher needs to fundamentally withdraw their sense of superiority and knowing, and allow every encounter to begin with respect for the uniqueness of the person to whom they are relating. The best teachers are also students; they are life-long learners. Ultimately, the way you treat others will offer you an insight into the way you treat yourself.

Feedback

Another indispensible resource in design work and a primary element of any desk crit is feedback. It comes in many different shapes and sizes and can be so tricky that the topic probably needs to be a stand-alone course. You need a strong ego to enter into conversation about your work, but if you are too full of yourself it is difficult to get anything out of such a conversation. This is as true

for teachers as it is for students. There are two kinds of feedback: the kind we give ourselves and the kind we get from others. In both cases our ego can be pivotal to making feedback useful.

A good place to begin is with the feedback we give ourselves. Imagine that there are three levels of this kind of feedback: head, heart and gut. A fourth response, which is a composite of all of these, is an integrated response. My benchmark is the experience of focus that I have when I am meditating or studying something that I find intensely interesting, when I can really concentrate and I have a sense of calm clarity. Whenever I have this experience while creating, I try to get out of the way and let that energy take over. The next level is the heart, where I experience a more emotional and expressive level of creative passion. I feel moved by what I am making and drawing and have a strong emotional connection to the design. I may even be in love with it, swept away by it. The gut level is the most instinctual level of connection and at this level I feel compelled to write, make and draw. I have no choice. The creator at this stage may feel that he or she has superhuman resources. Sleep? Not necessary! I do not consider myself to be the strongest person physically, but in a canoe I can paddle for days with very little rest. When that energy is present while I am creating something, I know that I am on the right track. The presence or absence of energy might be the best measure of creative drive. Just as feeling energized is a positive sign, having no energy for our creative work is a sure marker that we have lost a connection with our creative selves.

We can experience these kinds of feedback when we work both alone and with others. If we open ourselves to our own levels of awareness, we can equip ourselves to offer feedback to others. There are many paths that unfold in the course of creative work and getting to know our own relationship to creativity is a good place from which to learn how to help others.

There are some basic rules that make feedback helpful rather than destructive: practise non-violence; avoid low blows; when uncertain, ask questions. Avoid saying, 'You should . . .'; known in the language of psychology as a 'parental introjection', this can be very polarizing and can stop creative energy completely, because sounding too much like a parent automatically makes the other person feel like a child. Having an adult-to-adult conversation means using sentences that begin with the word 'I' not 'you', 'I think' or 'Have you thought about trying . . .'. It is also important to make sure that you are not offering feedback as a way of seeking power or taking control of the process. Sometimes I find it helpful to preface my comments by acknowledging that my viewpoint may be wrong. I learned this from watching the American detective series *Columbo* on TV. The important point is to give as much power and confidence to the other person as possible, while still speaking truthfully. Take the time to figure out the best way to express what you want to say. I think there are times after a desk crit to simply ask a student, 'Was this helpful or how could I have been more helpful? Have I left out anything that you think needs to be discussed?'

Learning how and what to draw will be just the beginning of an architect's education. Studying the history of cities, art and technology is as necessary as learning about structures and sustainability and visiting great cities, landscapes and buildings. Students can add to this foundation by learning to analyse building sites and programmes, and to keep up with building types and building regulations. How do you weave all of these threads into a single stream? Simple. Just start to design. Everyone's education rests on their ability to master increasingly complex design 'problems'. A first-year architecture student might begin with something like a house, move on to a small institution such as a community centre

or branch library, and then be ready to tackle a skyscraper. We learn about design by solving more and more complex design problems.

Were design only about problem solving, mastering this escalating complexity would be ideal. But design is not just something we need to learn to do, it is something we need to learn from. This happens primarily at the desk crit. The greatest concentration of time and energy in an architect's education goes directly into the design studio, the setting for the desk crit. It is here that the form and flux of our design-learning happens. It is here that we get feedback, experience design revelations, and learn how to let go of what does not work. A good desk crit is a micro-learning environment that holds an extraordinary range of creative and emotional states, always in service of learning how to make design better.

A student came into the studio one day to discuss his thesis. He had several ideas and had developed them, but he was not showing much enthusiasm for his project. Our conversation fell into an uneasy silence several times. Finally I reminded him that the final decision of a thesis topic was his. I did not know what else I could say. Then the student said, 'I always have trouble making up my mind. I never know what to do. I prefer it when someone tells me what to do.'

I told him that I had had the same problem when I was a student, but this postgraduate programme called for him to generate his own self-directed course of action. This was a big change from his undergraduate studies, where he was generally told what to do. He was expected to go from dependency to autonomy without much support. Trying to help him, I asked him what he liked to do outside of the studio. To my surprise, he answered that he really liked cooking and he often made dinner for his friends. 'What else?' I asked. He mentioned playing the guitar. Again I asked, 'What else?' This time he mentioned watching his favourite television show. And so there it was. I had known this student for some time, yet I would never have guessed these things about him. He seemed to be a quiet sort of intellectual, but everything he talked about was visceral and physical. He lit up and seemed full of energy when he talked about his cooking and love of music.

How could he bring that passion into what he was going to study for the next year? I suggested that he write a few paragraphs about why these other activities inspired him. Where did his passion come from? What happened the first time he tried cooking? How did he feel when he was playing the guitar? I believed that he needed to allow himself to enjoy his desires. It takes a strong ego to serve our creative instincts. I could see his energy change and become more animated and confident

as he shared his passions. He had thought that he needed to be some kind of idealized, intellectualized postgraduate student, and he had completely ignored his own nature. No wonder he had no idea what to do. He had left himself out of his own process. He so wanted to fit into the institutional norm that using his hands to figure out problems made no sense. In the end, it was all that did make sense.

When you ask students, 'Who is your favourite designer?' or 'what is your favourite building?' they are often reluctant to answer because they know that the answer reveals something about them. In my opinion the 'what' or 'who' is far less important than the 'why'. Becoming confident about what you like is very closely aligned with accepting yourself.

The following are two exercises that I have found helpful in making these inspirations conscious and that help to integrate them into a creative life.

Creative Timelines

Begin by drawing a horizontal line to show your life measured in years and mark significant creative experiences on this timeline. It could be a song you heard, a book you read, something you made or a conversation you had – any time that you were moved, any experience that made you feel at one with the creative spirit. The timeline is a history of who and what inspired you: every event, dream or relationship that helped you grow creatively. If you are uncertain about what to include, just allow the questions to sit with you for a day or so and through the process of gentle reflection everything will sort itself out. When you have your timeline, think about each experience. What it meant to you at the time, where it happened, who was there and why it matters to you now. Reflect on the people and events that have helped support you and the creative spirit that has been with you through all of these experiences. An important part of this, and something that I think is worth writing about, is simply what has been helpful to you. What caused you to feel more alive and creative? When you have finished, it is very useful to share your experience of your completed timeline with a good friend.

Visionaries

The second exercise is the following. Choose three people or things that have deeply inspired you. Once you choose them, write a letter about why each of them matters to you. Be very specific and detailed. The process of deconstructing these inspirations is the process of integrating them more consciously into our current creative life. We are trying to befriend the unconscious energy of these experiences and make it available in the here and now. We are asking these energies to come into our lives. They have been secretly toiling on our behalf for some time and we need to acknowledge and support them. They have more to offer if we are willing to recognize them. An additional step is to imagine that these three characters meet and are ready to guide you in your current creative work. Feel free to ask them questions and imagine their responses. Again, write out the ensuing conversation. This exercise allows you to more consciously use your imagination as a creative resource.

A student who came to see me after working with these exercises said that he had never realized where his creative instincts came from, but that he now could understand the arc of his creative life. For the first time he understood why he wanted to be an architect and why he was attracted to certain kinds of creative experience. Like all of us, he had a unique and unlikely collection of inspirations. He had discovered an important part of his creative self and this discovery would allow him to live more abundantly and confidently.

Channelling Design

MY FAVOURITE POSTGRADUATE course when I studied psychology was called Pain Management. It was an introduction to the various approaches that a therapist might use to help alleviate physical and emotional pain. During the course I was introduced to the basics of modern hypnotherapy and heard that there was to be a conference in Philadelphia on the work of the twentieth-century hypnotherapist Milton H. Erickson. Although some considered him a maverick, Erickson is widely recognized as an original contributor to the field of hypnosis and is credited with inventing dozens of creative hypnotic techniques and protocols. The more I learned about his life, the more I appreciated his approach. As a child Erickson was faced with life-threatening polio and many of his hypnotherapy skills emerged from his understanding and management of his own painful disability. Although he survived the original attack of polio and made a recovery, he was always affected by its symptoms and in his later years needed to use a wheelchair.

Erickson was renowned for his keen sense of observation, which he used to great effect in conjunction with natural induction strategies. During an initial interview, he would listen carefully and try to see where the client's enthusiasm and interests lay, noting in particular his or her physical responses during the conversation. If a client enjoyed, for example, growing tomatoes, Erickson would begin to tell stories about tomato growing, using the patient's passion and expertise as a medium to embed hypnotic suggestions. Even the most intransigent clients were no match for Erickson, because they were not really aware of the fact that they were being put into a hypnotic trance. There are stories of patients who, when they received his invoice, would be upset because they felt that he had not done anything,

although they then grudgingly added that their symptoms had mysteriously vanished. Erickson recognized that the conscious mind might sometimes want to quit smoking, but the unconscious mind was opposed to the idea. For some clients it was the opposite. Their conscious mind might not want to quit smoking while their unconscious mind might really want to do so. For this reason Erickson explained that it was important to know which part of the mind to speak to.

I was immediately attracted to this approach and decided to take a two-year course in Ericksonian hypnotherapy. I completed the course by helping a client quit smoking. He went into a deep trance and experienced a dream of being in an alpine hut that was filling with smoke, which only cleared once he had opened all the windows. When the session ended, he remembered nothing of the hypnotic induction, but afterwards completely stopped smoking. My ability to work with hypnotic states was supported by my background in Buddhist meditation. From this perspective, trance states, whether generated through meditation or self-hypnosis, were physiologically similar and I used subjective physiological markers to train myself. It naturally followed that when faced with creative projects, I began experimenting with using self-hypnosis. I generated a deep state of relaxation of mind and body as a platform on which I could then test and explore physiological responses to creative work. The deeper my relaxation, the greater my focus became. In these relaxed states of awareness, ideas and imagination flowed without friction and subtle physiological responses became clearer. I began to pay close attention to how my body and mind responded to ideas. After a while I was using this approach for everything from planning the studio curriculum to making design decisions. I created a deep sense of physical relaxation and then watched carefully as questions dropped like

pebbles into a pool. I gave my complete attention over to observing how the ripples felt kinaesthetically. Whenever my inner creative circuitry said yes, I went with the decision. Over time I felt more and more confident about trusting these cues. These techniques formed the basis of most of my creative decision-making, which I would then cross-check through feedback from friends and colleagues.

Around this time a friend introduced me to the work of Neville Goddard and I began to add a new element to my practice – the technique of holding in the mind a scene that represented a fulfilment of a desire I wanted to achieve. If I was preparing a new presentation, I would practise it inwardly, focusing on the feeling of delivering a well-received and helpful presentation. The key was to be able to realize the scene so totally in my imagination that my physiology would shift. It would feel as though my imagination and the physical sense of excitement that comes with doing good creative work came together in my imagination. After years of doing these and other related exercises, I wrote a book about them called *The Inner Studio*. Eventually I began to teach some of these techniques to students through a postgraduate course. My idea was that this way of working would give students access to their own inner resources.

I began by applying these protocols to creative work, but my real intention was to teach the ways in which these very same protocols were the foundation for healing. First, I taught the importance of dedicating any virtue accumulated through these practices to the benefit of all human beings. And second, I asked each student to write out his or her experiences before sharing them with another student. We spent time afterwards not only reviewing the exercises but also discussing at length what it was like to practise non-judgemental listening. Over the duration of the course the non-judgemental listening quietly took on greater

and greater importance. Watching and listening to a room
full of students sincerely intent on listening to one another is
always the highlight of a class. A university prides itself on the
importance of developing the intellectual and academic prowess
of students, but there are limitations to this. Anyone who has
worked in a group will testify to the fact that intellect alone is
not enough to ensure a group is functional. The same can be said
for leadership.

Body

MY FRIENDS AND I were sipping mint tea, wearing the towels we
had been given when we arrived at the hammam, the Turkish
bath. I was not sure what to expect, but ever since we had arrived
in Turkey each day had been filled with an unexpected adventure.
It began the moment we disembarked from our ship in Izmir and
there was a power failure in the port. We stood in the dark chaos
guarding our luggage until flickering lights were restored and
our passports could be stamped. We eventually travelled to the
ancient city of Ephesus and then to the great pools of Pamukkale
before finally boarding a bus to Istanbul, where the great mosques
and churches offered majestic and sublime escapes from the
intense streets of the city. A few days later we decided that it
was time for a massage. I was more than a little nervous when a
powerfully built man motioned me to lie down on a massive slab
of marble. He employed a series of moves that I vaguely recalled
from the sport of wrestling. Every time he pinned me to the stone
table my body had no choice but to surrender. My worries and
my bones were no match for his powerful manipulations and
soon I completely let go and yielded to the treatment.

I do not know how much time passed but when I woke up
I was alone in the dimly lit room. I had been stretched, squeezed,

pressed, pounded and rubbed. It was not a sensuous experience in the usual sense of the word: it felt more geological with the marble slab as final arbitrator. Using my arms to lift my body up from the rock I managed to walk back to a tiny vaulted chamber where tea was again served. Reunited with my friends, we finished our drinks without speaking a word and then got dressed. I stepped out into the bright city and immediately felt as if I was learning to walk again. Everything felt unfamiliar. My body had turned to earth and I had no idea what had happened to my head. I felt disoriented and almost drunk. I thought I was walking very slowly but in reality my pace had not changed. Then I suddenly comprehended what had happened: I was in my body.

Listening and receiving does not belong to or happen entirely in the mind. The body is just as intelligent and sensitive an instrument and just as capable of making wise decisions. Most of the time we think our bodies only tell us when we are thirsty or when we need to go to the toilet, but in reality the body speaks to us through a much wider range of symptoms that have the potential to signal whether it is for or against a particular thought or action. When we tune into this resource we quickly notice that we are constantly being signalled as to whether our bodies like a particular place, person or circumstance. The body is an undervalued resource, ever present and willing to contribute to the process of decision-making in design.

At the beginning of the term one student stayed behind after a group seminar. We had exchanged emails a few weeks earlier because she wanted me to know that her physical disability meant that she would not be able to finish certain assignments on time. This seemed completely reasonable. I told her that I was happy to let her set her own schedule and I was surprised when she told me she had never received such an offer before. On this particular day, she lingered in my office and started by telling me that the first few weeks of the term had not gone smoothly. She was being hard on herself for not keeping up with her classmates and had spoken with the university counsellor. She was now on medication for anxiety but she was not sure if she should continue with that medication or get it changed. She was struggling with the mounting pressure of assignments, even though she was free to set her own deadlines. I asked her if she could reframe her situation. Instead of thinking about her work and what needed to be done, perhaps she could think about her life and how she wanted to live. 'Let's remove every deadline and just begin with creating a schedule that agrees with your body,' I told her. 'Let's leave nothing out when it comes to deciding what's best for you.'

What began to emerge was a completely different idea about the term, a completely different idea of what university was for. She was not going to let her assignments have such power over her; for the first time in her life she was going to let her body have a voice in deciding what was best for her. She gave herself permission to take days off whenever necessary and not work to the point of exhaustion. She gave herself permission to take naps and to check in whenever she needed help. She started to take her life back and organized a schedule based on her own needs. Her disability had a new meaning – she would use it to learn how to make choices motivated by

what was best for her. Three months later, when the term ended, she stopped by to see me. It had not gone as well as she had hoped. Several times she had forced herself to do work she did not have the stamina to complete. She had been determined to finish at the same time as her colleagues because she felt that her disability should not control her. In the end she had not taken extra time for herself, even though she had permission from the school to do so. This limited how much she could get done and undermined her final project.

She told me that this ordeal had opened her eyes to her own negative bias against her body. Admitting that she was the one who had created these problems for herself meant she no longer felt mired in being a victim. She finally realized that she had the right to make decisions based on what was best for her. Her own body was teaching her this lesson. She told me that she had never really known what to do before. Now she knew. If we are willing to listen to our bodies they offer very reliable and liberating guides. Our bodies teach us to rest when we are tired and to trust our enthusiasms when we are excited. As an added bonus, we come to know our body is always showing us the value of staying grounded.

WHILE SOME DESK crits have been straightforward teaching experiences, some have also been about loss, confusion and disappointment. A student might begin by describing his or her project, but with none of the enthusiasm or engagement you would expect. After a few questions about the work, the student would admit to not liking the work he was doing. He might say that he had loved it in the beginning but now felt boxed in, drained, disinterested and disconnected from his work. The student usually had no idea how this had happened.

A pattern began to emerge as I listened to my students' frustrations and sadness. Every story seemed to spring from a similar place. They felt that they had lost their sense of power and their creative instincts. Some shared a remarkably similar account – some of their professors had used their positions as teachers to pursue power and had insisted on projecting themselves into their students' work. They did not allow for the subjective life of the student to play a role in the creative process. At that point, all that remained was a struggle for expertise, a tussle that the teacher would always win. Students would inevitably lose their confidence and sense of direction. Academic theory is not to be dismissed, but it is not intended to override all other aspects of learning. Design involves learning about autonomy. Rewarding students for a focus on pleasing others and behaving dependently is not helpful. There has to be room for freedom in a creative relationship. Even when the freedom results in failure, it is better than the failure that comes from surrendering one's own creative instincts.

On one occasion, when I asked a student what had prevented her from completing her work, she broke into tears, telling me that in high school her teacher had said that the way she was drawing was too 'childish'. She told me that her simple cartoon-like drawings had always excited her and inspired her to

become an architect. When this was taken from her, she was no longer able to move forward. When she had surrendered her way of drawing, she had given up far more then she had bargained for; she had given up what she loved and who she was. She had lost her way of expressing herself.

One student came to see me because he was having no luck making a difficult decision. He wanted to mention his father, who was a very successful developer, in his project. This success, however, masked something that was also missing from both their relationship and from the world of real estate development. He wanted to tie these two things together in his project, but his professor said that it was not needed in the work. The student, on the other hand, felt that without it he could not go forward. It was crucial for him to incorporate his father's unconscious attitude into his project. He was stuck. In the end, it turned out that he had needed to get stuck to build up the courage to defy his teacher's opinion and stay true to his own. In doing so, he was indirectly learning to separate from his own father.

It is not my intention to blame teachers for the various problems that students experience in their work. We all live to varying degrees under the spell of the unconscious and inevitably bring our psychological shadows to our work. Admitting that this is at the very least a possibility allows for a degree of vulnerability in the desk crit encounter. The experience of vulnerability may be a teacher's best defence against the devilish fit that blinds those in positions of power. Ignorance is the damaging normal that accompanies many relationships. The need for control coupled with a lack of respect for equal relationships is toxic. It poisons creativity.

3

Storytelling and the Big Idea

I WAS WAITING for a bus in Toronto's city centre and, as usual, there were none. After ten minutes of waiting, I decided to try hitchhiking. This was not so unusual in that area of Toronto in the 1970s, and as a young student – even one who was having trouble finding a summer architecture job – everything felt as though it had the potential to become an adventure. I waited with my thumb out, confident that a ride would appear. Eventually a Volkswagen Beetle slowed to a stop and the driver leaned across and asked how far I was going. 'Queen Street,' I said, and he replied 'Me too! Get in!' He did not look much older than me and he seemed friendly enough. I noticed that he was wearing six or seven wristwatches on his arm and after driving along a few streets I asked him about them. He explained that he was in the watch business, telling me that he had a really inexpensive source of watches and was making a killing selling them to small shops. He asked if I would like a job selling watches on commission. Frankly, he did not really look as if he was in any business, and I wondered if he meant that he was in the business of stealing watches. But he was a talented salesman and by the time we reached Queen Street I was ready to consider working for him. I took his card and told him that I would think about it. Had he picked me up to offer me a job? Maybe he was just looking for someone to practise on. I would never know because I never called him. I did not want to sell watches. I was looking for architecture work and was just too suspicious to let any apparent synchronicities interfere with my plans.

I eventually found a boring architecture job and two months later was back at school in London. Then, out of the blue, I received a letter from an old friend who was living in a farmhouse outside Assisi in Italy. He was running out of money and asked if he could stay with me in London while he looked for work. His plan was to make as much money as possible before going back to Italy, where he planned to continue living like a pauper and doing as he pleased. I had not seen him in a couple of years, but we had been good friends in senior school. I only had a one-room studio flat but I wrote back to say that if he was okay with living in tight quarters we could share the space for a while.

A few weeks later, my friend arrived with a small suitcase and big plans to make money. It turned out, however, that getting a well-paying job in London without a visa was nearly impossible. This was a huge setback, but it left the door open for him to find cash jobs. Still, it was hard to imagine how these jobs were going to do much to fill his bank account. Not only was making money proving to be difficult, but the tiny amount of money he had brought to live on was quickly disappearing. To make matters worse, there were unprecedented labour disruptions going on in London owing to widespread conflicts between the unions and the government. The government wanted to break the power of the unions and the unions were determined not to give in. One day there was a brief warning and the electricity went off in the city because of a strike by the power workers. There were threats that the police were going to leave their jobs. The London Underground started to close down at rush hour because transit workers were staging a strike in sympathy with the power workers.

While the politicians and union leaders argued, the city grew tense. The next threat came from the firefighters, who

announced that they, too, had decided they would work to
rule. They would, of course, put out the large fires, but were
otherwise working by the book. This news further stressed
the already fragile psyche of the city. Newspapers warned
everyone that London could expect Second World War-level
conflagrations. The city was reaching boiling point and yet life
somehow went on. The winter was as cold and damp as ever.
The weather was perpetually bleak.

My friend and I saved money by going to a Chinese noodle
place in a tiny two-floor building in Soho. A kitchen was tucked
into one corner, leaving little room for customers and even less
for waiters, who ran back and forth balancing bowls of noodles
and shouting at one another in Cantonese. Everyone ended up
sitting at tiny tables with three or four strangers as the place
filled up. Even if they managed to sit alone, the waiters would
make sure to send customers to join them. In this way, not an
inch of space was ever wasted. Customers rarely spoke except
to place their orders or ask for hot sauce. The waiters knifed
through the packed place while patrons protectively leaned
over their steaming bowls of soup. The upstairs was just as
intense as the ground floor. With the firefighters on strike
I could not help but think that building codes would never save
us – if there were a fire no one would be able to move. Most of
the customers were Asian, but at night all kinds of artists and
urban misfits seemed to find the place, no doubt because it
was so unusual for a restaurant in London to be open well
past midnight. So anyone who wanted a delicious, cheap
meal after that time happily joined this steamy brotherhood.

One night my friend and I were sitting at a small table
on the ground floor when a young man joined us. I looked up
from my bowl of noodles and recognized our companion right
away. It was the fellow with the watches who had picked me

up when I was hitchhiking in Toronto. He recognized me too, but showed no emotion as he ordered a bowl of noodles as if he had been there many times. I asked him what had brought him to London. I assumed it was watches, but I was wrong. It turned out that when the firefighters had gone on strike, he had started a business selling fire extinguishers to small offices and shops that were obviously worried about the potential hazard of the strike. Before I could ask him any questions, he told us that he was doing really well. In fact he was making a bundle and was looking for sales help. My friend put down his chopsticks and began to listen; the next day he started working on commission. The first day he sold four fire extinguishers. The firefighters turned out to be fiercely stubborn and their work-to-rule campaign lasted several weeks. This suited my friend perfectly and he went on to have a brief but very prosperous career in the fire extinguisher business. A few months later, flush with cash, he went back to Assisi a wealthy pauper. Grateful for the free shelter I had provided him in London, he invited me to join him in Italy.

I told him that I would be happy to go, but it took six weeks before I figured out how to make the invitation work – I approached my Renaissance Architecture professor with a hastily devised proposition. I explained that while I enjoyed her course on the Renaissance, I was becoming fascinated with the medieval period and wondered if she would approve a final essay that examined the public spaces of Umbria. I calculated that this would allow me to use my friend's place in Assisi as a base. Writing this now, it seems to be an obviously ill-conceived argument, but in one of those inexplicable moments of indifference or kindness she agreed to the change of my essay topic. I immediately prepared to go to Italy. I took a few weeks of Italian-language instruction and went to the

British Museum reading room, where I began to study the
hermit-like hill towns of Umbria. Every day for two weeks
dusty tomes were delivered to my desk in the magnificent
rotunda of the library. I pored over old maps and read idyllic
accounts of Victorian travellers riding donkeys from town to
town. I selected a route that would have me visit Orvieto, Todi,
Perugia and finally Assisi. My plan was to spend about a week
in each place, blending my observations with the historical
material that I had studied to arrive at a theory about what
made public space so vital to these towns. I chose four towns
because in my mind the number four was the minimum
number to describe a square. I read up on each place, made
notes, studied hand-drawn maps and booked a flight to Rome.
I would finish up outside Assisi, where I would complete my
essay before returning to London. According to schedule,
I arrived in Rome and travelled on a train full of troops who
were searching for the recently kidnapped Italian politician
Aldo Moro. I arrived in Orvieto in time for Easter mass, which,
owing to the political unrest in Italy, had been moved from the
Vatican to the Duomo.

The Italian love of food and the patient invitation of ancient
spaces was pure bliss. After a winter in London, the light and
warmth of Umbria seemed like heaven on earth and I travelled
from town to town in a state of architectural euphoria. Each
town was distinctly itself and no place tried to be anything but
itself. Each town had its own story woven from topography,
history and fate. When I finally arrived in Assisi, its soft pink
light completely charmed me and I happily settled into my
friend's old farmhouse on the edge of town. We lived simply. In
fact, we did not even use any cutlery for two weeks. We cooked
everything over a fire in a big medieval fireplace. I completed
my history thesis, now called 'Four Squares in Umbria', and

returned to London to hand in my essay. A few weeks later I received the following note from my professor: 'This is a work of love and as such suffers from the inevitable problem of infatuation.' Mercifully, she gave me a passing mark and many years later I still think of her with gratitude.

Not only have the lessons learned about public space in Umbria been fundamental to my appreciation of architecture, but the entire experience was filled with a generosity and joy that went straight to the heart of my creative instincts. I like to think that my professor had also trusted her instincts and the result was one of the highlights of my education. Connecting with and then staying true to your creative instincts means opening a large door that leads directly to the great liberating adventure of life.

The Idea, the Whole Idea and Nothing But the Idea

The 'big idea' is the engine and narrative of a project. It contains the code and inspiration for the project; it is the job to be done. It is a story that, at its best, marries aspiration, ambition and vision. Saying 'my project is about . . .' is like saying 'Once upon a time'. A great story grabs our attention because it invites and then involves us. We want to follow its lead.

At its core, the big idea belongs to the human tradition of storytelling. It not only explains to others the main idea and ambition of what we are doing, but serves to remind us of what is important as we navigate the complex waters of design. In architecture, as soon as we have the big idea, we have to make something of it, and often what we make is a drawing – also known as the parti. The parti is a drawing that organizes the intentions of the project. It is not a plan or a diagram of the building. It magically communicates by embodying the emotion and atmosphere of the big idea. The

parti could be a physical model or it could be some understanding of landscape and spatial intention. It both holds the idea in place and offers a glimpse into its future. It is the design in a nutshell and, as an added bonus, it communicates in a language spoken by every designer.

The big idea guides the design process. It establishes the territory and organizing principle. It does not need to be overly complex because it is going to become complex through development. It does not need to have figured out the problem because it is going to evolve and grow through the process of design. It needs to be clear enough and resilient enough to withstand the rigours and debates of development.

The big idea is part lens, because it influences what we see, and part door, because we go through it to arrive at the completed work. It is part fire, because it illuminates. It helps us to know where we are going but it never limits us. It offers us a sense of knowing and control, even though the process of design often seems slightly outside our knowing and control. Whenever we face design uncertainties during the development of the project, we can return to the big idea for direction, guidance and deeper investigation.

I THINK OF design as a kind of sacred activity. Not only do design decisions exert influence over many people, but the way resources are used has a real impact on local environments, issues of inclusivity and, ultimately, on global issues such as climate change and species extinction. We are just learning to think about issues that exceed the lifespan of a single designer, such as operating costs and the life cycle of materials. The days of operating without global obligations are clearly over. But the roots of creativity remain a mystery. With most things we rely on a strong ego to get what we want, but the ego plays

a secondary role in creative work. Creativity is not something we get but something we receive, and we have no real control over the creative timeline. Who knows when inspiration will strike? The challenge of creative work is knowing what to do with the ego. We need it, but too much of it, particularly at the wrong time, usually spells trouble.

Because of this reality, over the years I have become more and more attuned to the idea that we need to say grace before we begin creative work. Not necessarily to absolve us of responsibility, but to declare our deepest intentions before we begin creative work. You often hear, 'I created this' or 'I designed that', and while this may be true from the standpoint of the ego, from the standpoint of the creative spirit it seems clear that there is a higher power involved. Creativity is a gift – it is something we receive. As I get older I feel more and more gratitude when a good idea comes to me. To make space to receive the creative spirit, internal conflicts need to be consciously declared and wrestled with so they do not unconsciously undermine our work. What do you care most about? Whom and what do you love? What would you like to see more of? What would you like to see less of? What kind of world do you want to live in? What kinds of places and experiences make you happy? A conscious and deliberate inclusion of this when you set out to design something is obviously going to influence the arc of the design.

When I was studying psychology, we were asked to shadow a healthcare worker for a day and get to know what his or her routine was like. I did not have a specific clinic in mind, but I had been treated by a elderly chiropractor who had the most wonderful disposition and I received permission to spend the day with him. When we met on the appointed morning, I asked him what he usually did at lunch. I expected to hear something about catching up with paperwork and filing reports. But no, he

said that he typically ate lunch alone in his office and then called
his wife. This left him a few minutes for reflection and prayer.
Prayer? I was surprised to hear this and asked, 'What do you
pray for?' 'To be guided so that I can be of service to everyone
I see in the afternoon,' he replied.

You never know the role your heart can play in creative work.
At times you need to fight passionately for your ideas, while at
other times tenderness opens a door or kindness reveals a hidden,
delightful quality. What is the greatest intention we can have?
To be famous; to create something that will be remembered for
a thousand years; to have a project benefit many people; to have
this project bring out positive qualities in all who encounter it;
to enable this project to embody and demonstrate affection for
the earth; to want all people working on this project to experi-
ence well-being and happiness; to let the creative spirit fill this
project with sustainable harmony and bring a sense of wisdom
and joy to all. Just as I wish for this process to be successful,
so may all of my colleagues enjoy their creative experience.

What people ultimately enjoy about creative work is that
they get to experience the creative spirit, perhaps even to be at
one with it. Bob Johnson, a record producer who worked with
Bob Dylan early in his career, remarked that he saw his job as
that of getting out of the way. When certain musicians began
to play, he explained, you could tell that the Holy Spirit had
come into the recording studio. He just tried to capture what
happened.

An unlikely enemy of getting started is having too many ideas. In our desire to solve the project, we try to address everything. We have five important ideas about the design and we try to follow all of them. The reality is that we need only one idea to start, and having one idea is more productive than having many. The reason that we need to hold to a single idea is that it allows us to form a hierarchy of concerns. It is simply impossible to give equal attention to all the ideas that go into designing a project. By choosing one idea, we force a hierarchy to develop. The evolution of the design happens through design development, where the architectural language of the project can be expanded.

I see my job in the design studio as that of a guide or coach. And because I am not caught up in the drama of creation and am not attached to a particular way of achieving a result, I can focus on being open to being moved by an idea. Sometimes I feel like a naturalist sitting and watching for something extraordinary to land in a pond.

If a student really insists on needing several ideas I might suggest developing all three, knowing that deadlines and other pressures will usually naturally focus their efforts on a single theme.

MY FINAL STUDENT design thesis was for an urban cemetery located near the Royal Opera House in Covent Garden, London. At the time, there were two vacant streets nearby. I knew the area well because I lived close by and I walked up, down and through the site for weeks. At the time, I was reading about Egyptian funeral rituals and studying contemporary burial practices. I was looking into traditional cemeteries in the major cities of Europe. I went to the Spiritualist Association of Great Britain and attended a seance, where the living were reunited with their loved ones through a medium. One day, as I was walking back to my studio, I suddenly realized that a cemetery

is a place of reconciliation between the living and the dead. Right away I knew what my big idea would be: 'the cemetery as a place of reconciliation'. I rushed to the studio and drew a parti showing my site as a dense city filled with gardens for ashes, each one the size of a small city block. Each of these garden areas was bound by a generous colonnade that would allow mourners and non-mourners the amenity of shelter. The entire site would become a city of the dead. It was going to be a public space for individuals and groups to expand their relationships with the departed, and a place to contemplate the meaning of life.

This phrase – 'the cemetery as a place of reconciliation' – did not describe the place physically so much as set a tone, atmosphere or quality that I could aim for in my design. It was sufficiently complex to defeat a simple diagram. It pointed to an idea and provided more than the need to solve a simple 'problem'. It gave me a sense of direction for the design. I knew that I wanted to make meeting places that connected both inwardly to the soul and with the dense surrounding fabric of Covent Garden. I also knew the place needed to be inclusive. Even if someone from the community wandered through the cemetery, I wanted them to feel a sense of belonging. Somehow these ideas powerfully guided me and I created a city where the living and the dead could both feel at home.

Much of the initial anxiety surrounding a project is finding a starting point, and it surprises students when you tell them that you need just one idea to begin. Usually we are looking for something perfect that solves every aspect of the assignment, and uncertainty often drives us to feel the need to have many

ideas. At the very beginning I might play with several possibilities, but as soon as one idea stands out, I go with it. One thing that characterizes a good relationship to an idea is our willingness to learn from it. Not every idea is equal, but the big idea will always contain something that excites our bodies, hearts and our minds. The best reason to go with one idea, if it is indeed the right one, is that working through it immerses us in the most fun you can have playing with chaos: design development.

Once we have found the big idea and are willing to throw ourselves into its development, we begin to build a narrative. Simply put, the narrative is the compelling story or argument for the design of the project. Design needs a strong and convincing narrative because it has so many adversaries: budgets, building codes and political issues, to name but a few. None of these are the problem; they are simply factors that increase the temperature to make sure that the story is well-constructed and fully cooked. In the case of my cemetery project, the narrative was not the design of a cemetery but the decision to make a place in the city that invited contemplation and reflection – a place where any citizen seeking solace and quiet would feel safe. The architectural narrative is the story that you tell yourself as that helps you transform information and ambition into a creative vision. Its function is to help you make design decisions. Will the front door and sense of address for the building be right for this location? The drawing is then turned into a story: 'As the guest arrives back at the cemetery, they enter through a door beneath a broad canopy . . .' This storytelling rolls around inside your head like a favourite song. It is shaped by constantly being retold and designed until it begins to settle into a consistent melody.

Whether you begin by examining the site, design precedents or themes, the alchemy of beginning a design project includes a desire to find an idea that is robust and open enough to sustain

rich and complex development. This catalysing moment is the fruit of the search for the big idea. Getting started means avoiding the terror of having nothing, which can make getting started the most difficult thing of all. There are so many possibilities. Nothing has been ruled out and nothing has been declared. On one side are the unknowns and on the other side are the factors to consider. Amid all this, waiting to be summoned, are our creative instincts. In our techno-society, with so much information available at our fingertips, the greatest adventure can increasingly be in the not knowing. Creativity is a refuge for those who are excited by uncertainty.

The creative impulse is what moves you and powers the design process. It is an energy that causes you to say yes or no to a thought, feeling, image or pair of shoes. It may call you to go jogging or to play the harmonica. It may come from running with dogs or working in the garden. It may even come from choosing what clothes to wear. Whatever is calling you – whether you hear, see, feel, sense or think it – you have been summoned. The great question is then whether you will respond to the call.

Warning: you may not hear trumpets. There may be no twenty-one-gun salute. You may hear only whispers or feel subtle tremors. You may need to be really listening inwardly. What brings the creative impulse may be a book that speaks to you. It may be a feeling of delight in your belly. There is no single description of how each person experiences the creative impulse. For me it is a force. I always feel good when I say yes to it and often feel unsettled when I ignore it. The beauty of this call is that over time you can learn to recognize it – to be receptive to your own particular inner call of creative communication. As you get more and more practised at identifying the creative impulse, you can learn to trust it, act on it and share it.

It is the subjective point of view that connects us to our personal needs and desires and ultimately to our creative instincts. When this connection is severed, vitality, the lifeblood, quickly drains from

the system. No blood means no fire and no fire means no creative spirit. If you feel that you have lost your creative spirit, you might as well take a break. Indifference and creativity do not mix.

When we say, 'I've got an idea,' what we actually mean is, 'I've received an idea.' The truth is you cannot set about 'getting' an idea. If you were able to, you could just schedule the time of your insights and ideas the way you can arrange to meet a friend for coffee. But it is impossible to schedule a particular time to get a great idea. A creative idea has to be received in its own time because it arises from the unconscious. We have no way of knowing it before we 'get' it. The part of you that uses the ego to get things done may be very developed, but this is not the part of you that is in play when it comes to creating. The creative impulse comes to you and the job of the ego is to receive it. Once you have received it, know that you have been blessed. If you could simply arrange to get it whenever you wanted, there would be no anxiety or stress associated with creative work. You could simply order it online like a new shirt. It is worth reflecting that often the missing ingredient in the creative process is wisdom. Wisdom cannot be taught; it comes through the intuitive function and is received in much the same way as creativity is received.

With practice we can begin to learn that the ego is really good at investigating and asking questions. One of the conditions that most engenders creativity, however, is the creation of a receptive inner environment in which the ego asks a question and then gives space, silence and time to whatever arises in response. Allow the ego to abide in awareness. The skilful and deliberate practice of creative design work arises out of the relationship between the right questions and holding this space of becoming.

The felt experience of the question is very important and is often neglected. It carries the all-important emotional attitude of the inquiry; too much desire will stop the process, while being too relaxed

will equally prevent anything from happening. The role of the ego is to stand guard and ensure that the most promising inner environment is poised for action.

What should you do with the creative impulse when you do receive it? Play with it! Each person has his or her own way of playing with the creative impulse. For some people it is visualized: the idea or image is held in their mind's eye, allowed to unfold and transform. Some prefer to watch what happens when they make suggestions, seeing how the many forms of the creative impulse feel as they are played out.

To play creatively means suspending the normal rules. Imagine a young child eating with her hands. She has a big grin as she lifts the chocolate cake from the plate towards her mouth. Her hands are enjoying the lifting; her mouth is open; her eyes widen. Eventually there will be chocolate all over her face and hands, as well as her plate, her shirt and the floor. There will be a big mess. And a big grin. Delight! That's play: the normal rules of eating have been suspended. It is not aiming to be civilized or perfect. It is not aiming to please others. It is about being free of these rules and allowing the body and mind to celebrate.

To nourish an idea, the creative person needs to be with and to revel in it, to watch it with affection and curiosity and to investigate it. The creative individual needs to treat the idea like a brand-new living thing that is not yet able to stand up and walk on its own. If you are not sure where to go with a particular creative act, bring it into your heart and listen. Ask yourself, does this agree with my heart's desire?

There are various things that can get in the way of this process: an intolerant attitude; anger; the internal voice that tells you to stop making a mess; the voice that berates you, telling you that you should have figured this out days ago; the voice that tells you it is too late and you are too stupid, that you should stop wasting your time; and the voice that says, 'stop being a child'. Ignore all of these

negative voices in spite of what you may hear, and tell yourself that this is your time. The creative impulse needs your complete attention and support. Give yourself permission to play with the ideas. Proceed as though the gods above are inviting you to be at one with the divine spark. Practise being tolerant with yourself. You are in a completely safe place and no harm can come of this.

Does this mean you will not fail? Absolutely not. But it allows you to store up the kind of experiences you can draw upon when things get difficult. It also gives you something to refer to for when things are going well.

Another obstacle that can spoil the creative process is having too great an expectation of what must happen. Expecting to manage a creative process perfectly is crazy-making. It is better to tell yourself to enjoy the creative ride with all of its inevitable ups and downs than to try and control its waves. Failing to protect the creative impulse can also cause problems. It needs to burn brightly, so let it.

Perhaps the greatest obstacle, though, is trying to be perfect. This urge afflicts us all. We so much want to be successful that we can fail to allow for human imperfection. The fear of making a mistake greatly reduces the options we are willing to consider. When starting a project, think about it the way you would if starting a fire. The conditions may be challenging. There may be a chance of rain; the wind may be too strong. Given these circumstances, you have to nurture and protect the fire until it has a chance to develop. When the first waves of self-criticism or imposed rule-making begin, protect yourself from them. If they are unrelenting, try writing out the phrases you are hearing inside yourself. The repeating phrases may have been running on a loop for many years. Writing them out weakens them because they cannot thrive in the light of day. Their power is greatest when they are not acknowledged, so bring them to the surface. Consciousness changes things. After you have recorded them, you can bury them in a field or burn them. They need to be cast out and put to rest.

As you allow yourself to play, the ego will begin to come back into the creative process. It may not be necessary when the impulse first arises; in fact, it has no role to play at the beginning. But it soon does. All the shaping, investigating and exploring, the rocking back and forth between knowing and not knowing, is a two-step dance that must involve the ego.

When we receive a creative impulse, we are at one with the divine, however you define it. We lose track of time when we are working on a project we love. This is the bliss of creating. The greatest thing you can do to befriend a creative state is to give thanks and be genuinely grateful when it occurs. At the end of a good day of work, practice expressing your appreciation for being successful. Our gratitude connects us to miracles and extends our capacity to share good things. If you are blessed with something from the great beyond, make sure to share your good fortune with those around you – or, if it agrees with you, share the feeling of being blessed with everyone on the planet, in the city or in the school.

WHEN I WAS thirteen I watched a television show called *The Prisoner.* The main character of the show, Number Six, was played by the actor Patrick McGoohan. He lived in a future world where he stubbornly resisted the unseen authority that called everyone by their number. His rallying cry to those in charge was, 'I am not a number, I am a free man.' I followed the show and fell in love with the car he drove, a strange little sports car that seemed to be from both the future and the past at the same time. After doing a little research, I discovered that it was called a Lotus 7. It had been designed by a famous British racecar designer, Colin Chapman, and was sold as a self-assembly kit as a way for owners to avoid paying vehicle tax. The car was intended for racing but could legally be driven to the track. It was extremely lightweight,

handled like a go-kart and became very popular in the world
of English club racing. I had never seen one in Canada and I was
overcome by the desire to own a car. It was my heart's desire.
I became totally focused on owning the car. The next summer
I found a job doing manual labour for a construction company.
My plan was to work for the next few summers and save enough
money so that when I turned sixteen I could buy a Lotus 7.

The summer job was my first real job working beside men.
The company had just completed a stretch of motorway and all
the signs that had been used to mark the construction zone had
been dumped in the construction yard in a tangled mountain
of debris, 9 or 12 metres (30 or 40 feet) tall. On my first day the
foreman, who spoke very little English and was missing several
fingers, led me over to the pile of tangled wood and metal, gave
me a hammer and told me to get started separating and stacking
all the metal signs and their wooden supports. There were
hundreds and hundreds of them. It was 6.30 a.m. on an already
very hot Monday morning, and I didn't think it would be possible
for me to complete the assignment in six weeks. I had taken on
too much. I was not just trying to climb a mountain, I had to take
one apart and then re-stack all of the components.

When the lunch van pulled up in a big cloud of dust and rang
its horn, I sat down and happily ate my food. When I stood up
to go back to work I noticed it was only 10 a.m. – I had only been
working for three-and-a-half hours. At lunchtime I had nothing
to eat because I needed all my remaining change to take the bus
home later. There was no shade, the heat was unbearable and my
work clothes were drenched in sweat. Sometime that afternoon
the foreman came over and built me a simple workbench. It took
him less than five minutes and it made a huge difference. When
the day ended at 4.30 p.m., I slowly made my way across the
dirt field to the bus stop to catch a bus to a metro station and

eventually to another bus that would take me home. About an hour and a half later, I was back at my parents' house in a quiet and leafy part of the city. This day had felt longer than my entire life and it was only my first day on the job. I had six more weeks to go. I felt as though I had entered into what felt like a life-or-death ordeal to buy my dream car. No one was home when I got there so I grabbed a piece of fried chicken from the fridge, ate it as I took a shower and then fell asleep on my bed. After what felt like only a few seconds, my alarm went off. I got up, dressed quickly, stuffed an enormous pile of food into my lunch box and marched to the bus stop to catch the 5.10 a.m. bus that would get me to work for 6.30. Except for new immigrants who were on their way to jobs like mine, the city was asleep.

I got through the summer and completed the job I had been assigned. The highlight of the summer was being taken off the sign job to help other workers break up concrete that had hardened inside the drum of a cement lorry. What kept me going was stubborn pride plus an incredible weekly pay of $200 and the knowledge that my dream was becoming a reality. I worked the next summer and managed to save $2,300. Then I got my driver's licence and began to search for the Lotus. I found a garage that serviced British sports cars and the staff there would occasionally take me for rides in the cars they were repairing. There was no sign of the Lotus.

Finally, the following spring I came across an advert for a second-hand Lotus 7. It had been raced in British Columbia but was road-ready and available in a garage on the outskirts of the city. I drove there with my father. They wanted $2,300, but I managed to get the car for $2,200. My father agreed to lend me the money for insurance and about a week later I picked up the car. I pretended to know what I was doing and drove home as the happiest man on earth. The depth of joy I felt was inexpressible. For the first time in my life I had fought for what I wanted and won the prize. The

car was even more fantastic than I could have imagined. I clearly remember having trouble brushing my teeth that night because I could not stop smiling. I felt as though the gods had helped me to steal fire. I was at one with what I desired – the young man who looked back at me from the mirror was someone I had never seen before. He was ecstatic.

When I was seventeen, driving the Lotus to school was pure joy. It was a cross between a go-kart and a racehorse. It was noisy, leaked oil, and had no doors or windows. Wherever I left the car, people would gather round to look. Getting into the car required the body of a yogi. Travelling down the motorway was exhausting and thrilling and would melt the rubber soles off my shoes. I can still remember getting up very early in the morning to go for a drive. The car was so loud that I would push it down the hill and slip into gear so that it wouldn't wake my parents.

At school I joined other car-smitten classmates and we drove around the city as though it were a racecourse. Travelling alone one day, I went around a corner too quickly and the rear of the car slid out and hit the pavement. There was a terrific thud and then the front end slid round and also slammed into the curb. I wasn't hurt, but I could see that the front end was bent. I drove home very slowly and inspected the damage. The frame was quite banged up. I took the car to my favourite garage and they didn't look too happy. The repair would cost $700. I asked my father for a loan but he said that I needed to learn a lesson. The accident had been my fault and I felt terrible about that. I had no money and no choice but to sell the Lotus back to the garage. They took the car in a trade for a more ordinary British sports car. It was a nice little car, but it meant nothing to me. I drove it through the summer to get to work so that I could pay my father back for the insurance and then I sold it. My interest in cars came to an end but the event generated

an important lesson that had a lasting impact on my approach to teaching.

If you have experienced an environment where you were not supported in your interests, you may find that your drive, your ability to welcome your heart's desire, has been compromised. For this reason, teachers, who take on the unconscious role of a parent, need to be very careful around criticizing a student's interests and ideas. This is not to say that criticism is always unwelcome; it is necessary, but we need to make sure that it is not soul-destroying. There needs to be a good connection and a positive environment to ensure the student has the energy and know-how to move forward on his own. My approach when I find a student with a project that has stalled is to try and discover at what point they lost their passion. Rather than criticizing the project, I want to focus on recovering the creative thread of the project. When a student reconnects to their passion it's easy for them to move ahead. Criticism is important, but it is a love for the creative process that drives design work forward. We have no command over when the creative spirit will move us but we do have control over the habits we bring to the process of design.

FOR MANY YEARS I taught a course in which students were randomly assigned a symbol and an animal and asked to make an architectural installation inspired by the two. Before they began, they had to get to know their animal: how it communicated, moved, survived and socialized, and the ways in which it had been mythologized. The symbol was a word like 'horizon' or 'knot' or 'blanket'. The assignment was like a zen koan and if there was a 'right' answer, it was only accessible to those who were present in the moment-to-moment creative instinct. It always surprised me how much students rallied to the exercise. It was as if each student had a wellspring of creative energy and

wisdom waiting to be awakened by the animal. How would
a salmon solve this problem? How might a raven see this? These
were the kinds of unanswerable questions that were discussed.
To understand this exercise, think of the Ford Motor Company
and the mustang, the animal that is a key part of their automotive
strategy. Think about Penguin Books or Dove soap or the Red Bull
energy drink. In every case, these modern corporations know that
there are many levels to human beings and the instinctual or animal
part of us is well worth contacting, and even influencing, because
that part of us is, unconsciously, very capable of dominating our
decision-making.

The part of us that is more attuned to instinctual energy than
to rational thinking is fundamental to the decision-making process.
Marketers often try to speak to that part of us. But we can also
learn to use that same energy creatively. Although we may not
acknowledge it or be conscious of it, our brains are wired to value
these instinctual energies – sometimes we are only aware of these
strata when we make the wrong decisions. Carl Jung saw creativity
as a special kind of human instinct. I wanted students to experience
the instinctual energy of creativity and to not let thinking over-
whelm their capacity to imagine.

Some of the installations from this course were there only to
be looked at, while others involved us in a web of play and wonder.
The amount of work that went into these projects was only possible
owing to a profound level of cooperation that the behaviour of their
assigned animals somehow induced in the students. Egos were set
aside and a spirit of cooperation took over. We sat in silence and
were transformed. After several years, the presentations began to
turn into ceremonies in which each installation unlocked a new
way of seeing the world or of reflecting on the meaning of life.
At the end of the presentation day, we spontaneously gathered
around a fire and gave thanks. I was surprised by the freedom and

refreshment the students felt when they were allowed to access their creative instincts. The gravity of the work stayed with everyone for a very long time.

Y ou need only one or two ideas to begin. Then you take one idea and examine and investigate and play with it through the plan, section, vignette or model. Each medium brings a bias and another point of view. Just continue to experiment with a few minutes on each. Relax and let your mind be loose. Just play with it. I wouldn't worry about how much time it takes as long as there is some sense of flow – some people prefer setting a timer so you do exactly five minutes on each. The idea is to generate a flow. If you set a timer and shift from one of the mediums to another, it is helpful to do more then one cycle and I would experiment with doing at least two or three. Losing a sense of time is always desirable. That is how you know that you have found a happy balance of concentration and play.

The design process is called an art because it is not predictable. There is no formula, no certainty. I have seen students accumulate scrolls worth of design studies but because they use only one medium they remain essentially stuck. The rolls of darkened paper are not a sign of progress. In fact, being busy is not a sign of progress.

The reason to work with fewer ideas is to shift the experience from design alone to the process of design. Once you have an idea, you can use your emotions and instincts to give you feedback. As you develop your project, stay connected to the ways in which you experience the various developments inwardly. An idea can come from anywhere and be in any form. Whatever moves you – that's where you start.

At first the student was trying to smile, saying that this was difficult to talk about. Then she gave in to her tears. She told me that she tried to hold on to her ideas, but had never got good marks when she did. Now she no longer believed in her project, which called for the design of an art gallery. She had many things she wanted to say but she was experiencing an old feeling of defeat.

After fifteen minutes, when she had stopped talking and crying to reach for a tissue, I asked her to tell me how her project reflected all the things she so believed in. She had strong ideals and low confidence: the perfect storm. I tried to reflect back to her the strong beliefs I had heard her express. She was very concerned about the loss of habitats and species and upset with society for ignoring these realities. She believed that consumerism was destroying the world. How, I asked, could these issues drive her project? She talked about being deeply devoted to cities and urban design, and it was her belief that this is where everything started in architecture. Again I asked how these values could ring true in her work. She showed me her sketches, which embodied the things she was passionate about. We talked about imagining the art gallery as a special set of rooms in the city. The building could be designed to host a whole range of activities. There could be rooms for displaying art and there could be tall, uninhabited towers to attract birds. Slowly the gallery shifted from something conventional to something creative that stayed true to the way she saw the world.

After about forty minutes, her posture changed and her tears stopped. There was now a collection of drawings in front of us that represented her vision, but she was still worried that others would not like her project. They may not, I replied, but I asked her if she would abandon her values to please them.

Would she leave her creation behind because others did not share her sense of what was important? 'No,' she answered, and she agreed to move forward with her project. In the end, it was not the best project in the class, but it was the best project she had ever done. Most importantly, it gave her a sense of creative power that allowed her to believe in herself. Years later I heard that she had rapidly advanced her career and was in the midst of an impressive array of projects.

Protecting the Big Idea

Another student told me that the moment he had met with his professor, and had begun discussing his ideas, he realized that he had made a mistake. The professor had responded to the student's ideas with several critical comments and, later, when the student tried to resume working on his idea, he felt stuck. What had gone wrong? The student had done exactly what he was supposed to do. The professor had done what he was supposed to do, too.

At first the student blamed the professor for being critical, but then admitted that he was angry with himself for betraying himself. Before the meeting he had known that his idea was not ready to be shared, but he had gone to the meeting and in doing so had abandoned himself. And now because he was feeling critical and angry he could not be creative.

If the ego we have developed to help us get what we want is not the source of creativity, then what role does it play in the creative process? Our ego cannot predict when good ideas will happen or where they will come from, but the ego can be good at protecting ideas. It can serve the creative process by ensuring that a safe space is maintained until the idea is ready to be shared. This may drive the people around us crazy, but it

is necessary because our unconscious needs to know that we can be trusted. There are exceptions, such as when group work occurs, but these situations usually include agreements that prepare us for shared work. If you are the sole author of your work, there are times when you have to be completely faithful to whatever it is you need to create. It is like cooking rice – you may be tempted to check the progress and see if the rice is ready, but it is best to not lift the lid until you smell the rice and know it is cooked.

The more this student talked, the clearer it became that part of the difficulty had come from simply not knowing how to express what he needed. You would think a skilled communicator would not have such a problem, but whenever the ego is drafted into a new job it needs to learn a new language. Sometimes it is a lack of language that holds us back. In this case, saying something as simple as 'I'm not comfortable discussing my ideas right now' was the equivalent of suddenly being asked to speak Hungarian. The possibility that ideas need protection was totally foreign to him. The ego's principal role in the creative process is as enabler and protector of the idea. It is a gatekeeper devoted to taking care of the conditions around us so that ideas can be received, developed and allowed to flourish. The ego supports the creative process by ensuring that the conditions are right. When we feel safe, nourished and comfortable, we have all the tools we need in order to do the job. The ego is really good at building an environment in which ideas can thrive. The student knew what was best and was learning a life lesson about staying true to himself. Developing a strong ego is necessary when it comes to successful creative work. Willing to fight when necessary and able to let go when required, an educated ego is a wonderful creative partner.

How Do You Know if an Idea is Good?

The answer is simple. You know that your idea is good when it energizes you. Nothing is a better signal of a good idea. That does not mean that the idea needs to exist without debate and discussion. Step away from your work and see if the idea still moves you when you return. Discuss it with a friend. Try generating other ideas. If you continue to return to an earlier idea, that tells you that there is something more to develop. An idea can appeal to our intellect, our heart or our gut. Ultimately the idea needs to be tested in as many configurations and iterations as possible, and this best happens through the process of development.

Design calls for resolve and tolerance, acceptance and defiance. That is why the process can seem like such a mess. If you are ever stuck or blocked, try eating a meal without cutlery. Use your hands to get out of your head. Make a bigger mess than the one you are in. You may not know how it all goes together, but you can always trust that there is some pure realm where the magical idea is waiting patiently for you to arrive. The necessary factors are mental, emotional, physical and spiritual. Accepting that a mess often accompanies us as we travel to our goal is helpful. It reduces stress and anxiety because it undoes the burden of having to be perfect. The word 'mess' goes back to an old French word for food. We get the phrase 'mess hall' from that root. Learning that the creative life is an invitation to live at times with a mess of ideas, emotions and thoughts is a big relief. It helps us to enjoy the moment-to-moment experiences of the creative process.

4

Learning from Design

I SPENT MY first day of architecture school trying to choose between three different projects that were being offered to first-year students. One studio was organizing a street festival to protest a massive real-estate development that threatened to obliterate London's Chinatown. The second group would study the work of contemporary academic architectural theorists. The final studio would be designing and constructing a mobile pod that would contain the essential elements for living – after fabrication it was to be towed to a remote site where, for a short time, everyone would live together in a kind of transient utopian commune. What I did not know at the time was that we were part of an experiment intended to protest the ways in which architecture had been taught.

I chose the first group. Under the leadership of Jim Monahan we organized a street festival on Gerard Street in London's Soho. Timed to coincide with the Chinese New Year, we won permission to close Gerrard Street to traffic and attracted a large enthusiastic crowd. To our surprise, the event was featured on the front page of the London *Times* and helped bring attention to a rising chorus of voices protesting post-war planning principles that threatened to erase the historical fabric of London's West End including Covent Garden. We felt our work had made a contribution to protecting these precincts from large-scale modernist development. It was an incredible experience that brought history, politics and community into a single stream. The other groups were similarly successful, but as a class of young architects we were unhappy. We were hungry to learn how to

design buildings and we were upset because no one was giving us the chance. Our professors had a cynical view of the profession, but we were not moved by their arguments that architecture could not change the world.

The next term we staged our own protest and presented a petition demanding that we be given an architectural project to design. After some intense debate and negotiation we were victorious and our professors reluctantly gave in to our demands. There was plenty of excitement in the class when our first design assignment, a small house for an artist couple and their family on a site in Camden Town, was announced. We were finally being given the chance to become real architects! I remember clearly parts of my project, but mostly I remember the sheer passion, joy and terror I experienced during the six-week project. I had no idea what I was doing. Like most of my fellow students, I barely slept and often forgot to eat as I spent intense days and nights trying to make my plan 'work'. Once I had temporarily tamed this wild beast, I dived into drawing the section and attacked the most immediate and obvious problems I could identify. This, in turn, launched another intense and dramatic cycle of design as I tried to figure out how the section mattered in the plan.

Even though my design was simple, I found the relationship between the various drawings of the house infinitely complex. As soon as design conflicts between plan and section settled down, other unexpected complexities emerged. I discovered I needed to reconcile a window in the elevation with a door in the plan; then someone pointed out that the decisions I had made affected the site plan; no sooner did I put out that fire than I realized that new information about the structure required me to go back and rethink things. It was all-consuming and completely satisfying. I enjoyed solving problems (particularly in trying to fix the design problems). Every creative impulse seemed to spark a thousand

new design decisions and directions. I lost track of the weather and how many cups of coffee I had consumed. I was like a drunken passenger on a runaway train, but at least I could finally say that I was designing a building. Sleep-deprived and barely able to talk, our class raced to the finish line, making last-minute changes to drawings and models. It was exhilarating. It was chaos. It was architecture. The final reviews were an out-of-body experience of which I have no memory. It didn't matter. I loved the entire experience.

Looking back it is easy to see that my approach to design relied on turning large problems into smaller, more manageable parts. I had acquired this mental model of learning more or less unconsciously through many years of studying maths and French, and learning to play hockey. When I had successfully solved a small problem I moved on to the next problem. The good news was that every time I solved a problem I gained confidence that could be reinvested in further acts of problem solving. The bad news was that any mastery I gained through resolving a part of the design was at the expense of understanding the design's whole. I may have been learning to design; I was not learning from design.

Since my approach to solving problems seemed to work, I repeated it for my next design assignment and the one after that, until I had more or less discovered a way of designing that got me through each project. By the end of my third year I designed a community for several thousand people, and when I passed the course I assumed that I was becoming a good designer.

To teach design, one must give ever more complex problems to students – the actual lessons of design happen covertly. Once you have proved you can design a house, what about a small library? A mid-sized hotel? Follow this with a tall building

and then perhaps a sizeable community. Each step is more demanding. Your design abilities must develop or you will perish.

In my fourth year, my trusted way of designing collapsed. I hit a wall of epic proportions and had no resources to deal with being really stuck. In this existential crisis, my internal critic mocked every design decision I made. After flailing away for most of the design studio, I cobbled together a project that I had no enthusiasm for. Baffled and filled with fear and despair, I had no choice but to start again. I realized that I needed to go deeper into the process of design and discover something meaningful. Looking back I can say this was the best thing that could have happened to me. While failure is never a desired outcome, never underestimate its power to teach us the lessons we would least like to learn about our selves. I needed to learn that I did not have all the answers. I needed to learn that I could recover from failure. Nothing improves your chances of being a good designer better than failure. Humility is not something you can acquire intellectually; it is something learned from going through, in an honest fashion, the emotions that accompany disappointment.

It is probably a good thing that everyone has their own way of designing, because teaching design can be very tricky. As a teacher, you want to share your experience, but you also have to honour the many ways that individuals have of being creative. My ideas about teaching design are drawn in part from my own experience as a professional designer and in part from what I have learned working alongside young designers.

Developing the Big Idea

If the big idea identifies where you want to go, design develop-
ment is the process that determines how you will get there. The big
idea needs to be tested in order to grow and, as I have discussed
earlier, testing best happens by running the idea through as many
of the different conventions of drawings and models as possible.

Designing is the creative process of imagining your project into
existence. It is a process of integrating many factors, details and
requirements into a satisfying whole. At first, as is true of beginning
any new activity, the breadth of things to consider can be over-
whelming. Two things help to manage this. The first is a love of
what you are doing, which can help generate forbearance and
determination. The other is learning how to come to terms with the
hierarchy of concerns that every project faces.

If you ask an engineer, she may tell you that the structure comes
first. A landscape architect might say that the indigenous conditions
of the site are primary. A client may say that the budget takes pre-
cedence. The community may point to the shared concerns of the
neighbourhood. These are all valid. The issue for the architect is
figuring out how to combine all these points of view into something
that is greater than any single concern. Hearing all the points of
view but staying true to your big idea will naturally give your work
its hierarchy.

The many streams I have talked about come together through
the process of design, even though many of them will be in direct
competition with one another. As is true when we are learning to
drive a car, play the piano or speak a new language, we often feel
overwhelmed by all of the new information at the beginning. The
key thing is to remember to take breaks so that you do not get
drained or defeated. When you take a break, ground yourself by
doing something as simple as washing dishes or taking a walk. With

practice, things will change. As the once troublesome becomes familiar, we can begin to challenge ourselves with new unknowns. The big idea gains resilience. It is useful to keep in mind that when you are not sure what you want to create you can always ask yourself, 'What would be helpful to others?'

Testing

Design development is about testing the big idea in as many different conditions and situations as can be imagined. Does this organization work on this site? Does this elevation work with this plan and section? Design development is ultimately an exercise in investigation and the less biased we are in our approach, the better odds we have of uncovering fresh responses. This is my favourite part of the design process. The greater the conflict, the more interested I become.

Every time we test an idea using the various drawing and modelling formats that are at our disposal, our work celebrates a birthday. With each cycling through plan, section, elevation and 3-D model, our work grows a little more resilient. A precocious project is one that has not been tested and is able to claim only a few iterations. A mature and more meaningful project has been tested over and over again. This repetition is necessary. Another level of 'testing' that occurs is the very deliberate process of testing what works and what does not work. Not only are we trying to advance design ideas, we are trying to improve our design process by reflecting on which particular experiments and methodologies are most helpful. This allows us to continuously let go of steps that may no longer be useful or to incorporate new practices that make worthwhile contributions. Unexamined methodologies often hold us back as much as the ideas we are trying to develop. Take a moment to imagine a documentary film that surveys your approach to design.

What would you like to adjust or edit? What do you need less of? What would you like more of and what would you like to amplify?

Ask the questions of the project that you need to ask and then listen inwardly. Simply record what the imagination suggests. Most lights will be green and you can turn at any red light you encounter. This allows a subtle shift from critical to flow states. Harvest the full effects of the flow state and save the editing for later.

Drawing

Creating is always a kind of journey. The most memorable wilderness trip I ever experienced began in a car, then moved from a floatplane to a canoe, followed by a hike and a long drive. Over the course of two weeks, every form of transportation revealed something different about the landscape. We could have done the entire trip in a helicopter – that probably would have been most efficient in terms of covering terrain, but it would also have left out everything I remember as being remarkable.

My bias in favour of drawings has nothing to do with my own abilities. I really cannot draw that well. Nonetheless I have developed an ability to communicate with a drawing, so for me drawing is simply a way of communicating and expressing ideas. Think about how often you will have to communicate your ideas with others; the ability to use drawings will prove to be very useful.

There are multiple ways you can journey through design development: plans, sections, elevations, vignettes, physical models, details, precedents and computer-based models. If any one of these dominates to the point of excluding another, then something is missing. The optimum investigation uses all the available ways of journeying through the big idea. Each drawing offers a different 'metric' of the big idea and as each type of drawing moves the project forward it also offers you an opportunity to refine the

narrative. In fact the two activities of storytelling and drawing are really the principal ingredients of design. Having another person or a group with whom you can share this process of drawing and storytelling multiplies the creative opportunities.

Think of each type of drawing as a classroom. The project needs to go through many iterations if it is to develop and each of these iterations is a micro-excursion into development. I suggest taking a short amount of time, say ten or twenty minutes, to move through each type of drawing. What you learn from the plan is immediately applied and tested in the section. What happens in the section does not stay there, but gets brought to the vignette and then the model. Round and round we go, learning, shaping, advancing and retreating. Every medium brings a different form of nourishment to the project. Remember the meditation slogan that tells us to not have our minds too tight or too loose when we are investigating. If you are willing to take this approach you will never get stuck. Ideas can be nourished or starved by your choice of medium. Each medium has the potential to unlock a different aspect of the idea. When a particular avenue is not fruitful, simply change the drawing or model you are using to investigate the idea. Each medium delivers a particular perspective.

Design Language

The purpose of developing a hierarchy of ideas is to clarify the design to the point that we can start to discover the architectural language of the project. By design language, I mean the way that the most fundamental pieces of architecture are used to commun-icate the intent of the design: how are the walls, columns, floors and openings used to give the project its character and voice? I often reflect that both the greatest novel and the newspaper rely on the same alphabet. Even the most experimental poem is still

built from 26 letters. I see architectural language that way. It is the spatial alphabet we use to communicate our intentions. The potential number of combinations is infinite and a really important task is deciding which combinations to use.

As the project gains substance, the questions naturally become more explicit. What is this wall made of? What does this look like? We are now in the realm of the language of the project. Language answers these questions in a more direct way. What is the place like? What am I communicating and how am I communicating? Language, like all the other steps, precludes nothing but prefigures an atmosphere or experience.

Reflection

The most undervalued part of designing is what happens when we stop. The purpose of stopping, pausing and resting is to allow us to refresh our body, mind and spirit. It is impossible to keep track of all the potential influences and messages, ideas and possibilities during the design process. The mind is the centre of the operation and it needs a chance to take a break from production so that it has a chance to exercise its natural capacity to reflect. In a sense the mind is refreshed when it is not holding onto a position. This cycle of relaxation is often when the more subtle discernments and creative signals naturally emerge.

It is important to feel determined about your design and have a strong sense of being connected to what you are doing, but as useful as this mindset can be, it can also make creative work impossible. Listening can help with this. Even the strongest ego needs to be open to hearing new ideas – even hearing that it may be mistaken. One of the most important lessons of design is to be able to leverage the power of our ideas without losing the ability to learn from others and from our inner sense of guidance. It is

simply a fact that sometimes our heads tell us to go forward but our hearts are not sure. Or our hearts may be certain but our gut is upset with the idea. There are times to fight for what you think is right and there are times when reflection is the only way to settle an inner dispute over design. Cultivating a deeper and more sensitive ability to listen inwardly is a crucial practice during the design process. Sharing ideas with a friend can accomplish the same thing. The ego's ability to be influenced by opinions other than its own is not a concept that comes easily to most of us. I think it is a secret art that resides inside all creative decisions. My own path to accepting that I could survive being wrong was forged through multiple losses. I learned that you can be right or wrong about a decision. That's normal. What is not normal is to be right or wrong all the time.

First Thought, Best Thought

FOR MANY YEARS I thought of creativity as a heroic struggle filled with danger and suffering. I thought that these difficulties were an inevitable counterpoint to the joy that creativity always delivered. With experience, the creative work had more flow and the inevitable dramas were less involving. I realized that my internal mental model of the creative process was really conditioning the way that I approached my work and my expectations. I did not discuss this with anyone because what I had in mind seemed so simple that I was concerned that others would think I wasn't interested in the creative struggle. In truth, I am deeply interested in the innate creative experience and discovering to what degree the struggle is due to conditioning.

I had heard the phrase 'first thought, best thought', and learned that it was first used by the Tibetan teacher Chögyam Trungpa but had gained popularity when the poet Allen Ginsberg

began to use the phrase to describe a kind of fearless and spontaneous way for writers to find their creative voice. First thought, best thought seemed to me a path encouraging designers to trust their creative instincts. I began my creative experiment by adopting this premise and applying it to design work. Keep in mind that your first idea is not your destiny; it is simply your first step. It transfers the weight from 'What will I do?' to the all-important and decisive, 'How do I develop this?' There is a big difference. You are not locked into producing whatever your first thought might be. First thought, best thought really brings you into the moment and asks you to trust the process of design.

When I began to place the emphasis on development, I had to give up having the right answer right away and instead trust the experience of the creative process. Starting with 'first thought' as though it was a found object meant truly knowing that there is an underlying benevolent force that supports creative work. The phrase 'trust the process' has obviously become a cliché, but if you think back on creative work and imagine the implications of really trusting 'the process', it forever changes the vantage point of an author.

Starting with the way things are in the present moment means weaving all the elements together or accepting that the unconscious seamlessly weaves everything together. The film I saw, the music I was listening to, the people I spoke to, the place I visited, every thread was inevitably included in first thought, best thought. It also meant that I was forced to surrender the dream of being perfect. Nothing paralyses us more than the dream of perfection. First thought, best thought means that perfection is replaced by affection. The poet Charles Olson wrote, 'One perception must immediately and directly lead to a further perception,' quoting Edward Dahlberg. I applied this to whatever I was creatively investigating and found that in a short period

of time I had a solid idea developing. It was easy. There was always a flow.

I was once hired by an architect who specialized in small shopping centres and suburban office buildings. My job was to design buildings and hand them over to a team who would then detail the projects and prepare construction documents. There were five or six of us in the office and everyone got along. All I wanted to do was design buildings and this was all I was asked to do. From the moment I sat down in the morning to the end of each day, I designed suburban shopping centres and office buildings. A few months into the job, I started to become bored. My boss appreciated the work I was doing and started to give me more design work, but he asked me to repeat designs, wanting me to spend less time on each project. I had no interest in repeating myself, so to keep the job interesting I decided to take on the challenge of designing each new project as quickly as possible. First thought, best thought.

At the start of a project, I received basic information about the site, notes on planning regulations, and details about the clients requirements and ambitions. I sat quietly and visualized a few possibilities. As I did so, I observed inwardly how each of them felt. On a subtle level, using the intuitions of my body, I trusted the sensations of being energized, bored, curious . . . whatever felt strongest, I would go with it. I would not allow myself to have a debate because I wanted to stay as deeply as possible with my design experiment. Once I had a clear sense of the direction to take, away I went. I drew the project as quickly and spontaneously as possible, making changes on the fly and checking in with my team. The detailing was handled by a masterful Portuguese draftsman who was a true artist but had no interest in design. My boss was thrilled with the results because he would budget days for the design and I would be

done in hours. I worked in the office for a year and, looking back, I really learned how to read, trust and act on the concept of first thought, best thought. Years later I often found myself on the fringes of the city and would recognize a building that looked strangely familiar. Yes, I remember that one. I designed that. I am not claiming these were great buildings, but I felt fortunate to be in a situation where I was free to experiment with the design process.

Criticism

A large part of architectural education is based on criticism. Even the desk crit used everyday in architecture schools has the idea of criticism embedded in it. Criticism, however, can be corrosive or constructive. While some people say that in the end it builds confidence, it can also crush confidence and be defeating. Students who are not doing well often need the most guidance and lengthy criticism only triggers an attack of negative thinking. Because I never know the background of my students, I try to build a positive relationship with them first in order to brace them for my critique of their work. I sometimes follow the approach from the detective series *Columbo*, in which the actor Peter Falk began his summary of who committed the crime by saying something like, 'I know this is probably wrong and is probably a stupid question, but I wonder if you could explain what you were doing at three o'clock on Tuesday evening?' My version sounds more like, 'I know this is probably a dumb drawing, but I just want to show you what I think I hear you are saying.' I want to guard against making the student feel inferior. Adult-to-adult communication is the goal of every exchange; I aim to be honest but I am not out to overpower. A desk crit should be an adult-to-adult co-creative experience with a focus on the work at hand.

Visualization

I WAS HAPPY to get a call from old friends who were moving
from a small cramped house to a new place with more space
and who wanted me to be their architect. They were going
to renovate and almost double the size of the house. When
we met, they described in great detail the kind of house they
wanted, becoming increasingly excited as they showed me
images they had collected from design magazines and years
of travelling. They had dozens of ideas but confessed that they
did not know how to bring their vision into a coherent picture,
let alone a new home. They were hoping I could help. Little
did they know that I had a secret that I had been developing
and testing for many years, something every designer covertly
acquires and refines through years of practice. It isn't taught,
yet it becomes a remarkable design tool every designer takes
for granted. It is the ability to visualize.

Even before my clients had finished their presentation,
I found myself spontaneously visualizing possibilities for their
house. Their description of the various spaces had been filled
with unlikely juxtapositions and diverse ambitions, but I found
myself instinctively picturing parts of their house. At times I felt
as though I was walking through the spaces they were describing.
When they finished speaking, they asked what I made of their
desires and I began to lightly sketch a few images. Not only
could I draw sketches for them, but I restated their wishes as a
narrative that tied together many of the disparate details they
had talked about. They were delighted to see their private ideas
take form. Whether the project is large or small, whether it
involves collaboration with clients, engineers or building-code
specialists, it is the architect alone who uniquely brings this
ability to visualize a project to the table.

What interests me is that such a valuable skill is not part of the design curriculum. Instead, for most of us, it is acquired implicitly. Such an important skill deserves a more formal place in the design curriculum. Not only does it help in our relationship with clients, but it is immeasurably helpful in the forming and testing of ideas. The ability to visualize allows us to see our imagination. Visualization is a resource that allows us to not only see things in our mind's eye but to simulate events and settings and their relationship to one another.

When I was a fourth-year architecture student, I found myself stuck in a titanic creative block as days turned into weeks and I was getting nowhere with my design. I had read about Jung's work with guided imagery, however, and that gave me an idea: I would not try to figure anything out. I would not draw. I would not try to fulfil requirements. I would see what happened if I used visualization as a way of designing. I would begin to draw only when I could picture what I wanted to create in my mind's eye. I started to experiment by imagining the places and people who inspired me. I imagined an inner circle comprised of artists, poets and cultural icons – I would ask them for their ideas and then listen for their responses. Whatever they said, whatever images came to mind, I would draw on their behalf. All the drama and stress that usually accompanied design suddenly vanished. I trusted whatever came to me. There was no friction and the results were immediate.

A student emailed me to arrange a desk crit because she was struggling. We were at that point in the studio when most students' projects were coming together, but when I asked her about her project she showed me drawings that were tentative and colourless. There were some small gestural drawings that she had reproduced from her sketchbook and enlarged. They lacked context and together the entire presentation looked flat and detached. This contrasted sharply with the idiosyncratic projects she had pinned up at her desk, including some by the Swedish architect Sigurd Lewerentz. These aspirational, poetic projects were as fearless and particular as her projects were timid and directionless. I asked her about her favourite buildings and architects and at first she wouldn't tell me, saying that those were difficult questions. She was reluctant to identify what inspired her or what she liked. At her last desk crit, she had told me that one of the critics had said that her project lacked inspiration. Unfortunately, this seemed to be true. When I asked her about the projects she had pinned up at her desk she admitted someone else had suggested that she print out these images. 'What do you like about them?' I asked. She listed their best qualities and then began to cry when I came back to the question of what she liked. She acknowledged that she had always had difficulty with this question. 'I don't know why,' she added. What, I wondered, had caused her to live without a sense of what she liked or what she wanted? Can you create if you have no sense of what you like or don't like?

I did not really know what to say because she would need to be inspired to develop her project. There would need to be some joy in her work. Instead she looked like someone at the dentist's office waiting for a tooth to be pulled. She seemed unable to give herself permission to enjoy life. 'Name a designer you like,' I asked her. 'A musician. Something you like to do. Your favourite place in the world.' I gave her some examples from my own life. Then we went

back to her project. You could see the very beginnings of her desire in the work. I asked her to tell me about a few things that had influenced her life. She mentioned her Italian heritage and the Electric Light Orchestra. 'If that music could be a building,' I asked, 'what would it be like? What would an ELO design be?' I wanted her to imagine herself at a design brainstorming meeting surrounded by her Italian ancestors and members of ELO and ask them questions about developing her project. All she had to do was be the scribe and record their answers. Give them the design problem, I suggested, and listen for the answer. Just play with it. And though she was on the edge of tears, she was intrigued. I am sure she was thinking that it couldn't be that easy. But if we do not feel free to play with the things that inspire us, it is very difficult for us to move forward. This may not be all you need to do, but it is an indispensable step in the creative design process. Giving yourself permission to trust the things that move you takes practice but is necessary. I suggested that she try to do a version of her project where the influences would come straight from her favourite inspirations. 'If you get stuck, just come and find me – I'll be in the studio all day.' I did not hear from her that day, but she emailed me a few days later. When I went to her desk, she showed me tiny drawings that were full of an energy that challenged her somewhat tentative nature. Though she was unwilling to smile when she described her project, you could see that she was feeling more confident. As the term progressed, she continued to take small steps. She finished the term with a project that was still more potential than fulfilled but I hoped that a creative seed had been planted. In the end my hunch was that, rather than design a building, she needed to find out what she wanted to do with her life. She had been putting off the decision of what she really wanted to do. Though the journey might seem more difficult or feel unfair, once we discover what makes us happy everything becomes more meaningful.

After being blocked for a long time, I suddenly had several projects on the go. I felt as though I was channelling architectural ideas. I designed a house for D. H. Lawrence in the hills of Italy, based on his book about Etruscan places. I designed another building in Paris for Charles Olson, inspired by his *Maximus Poems* and my fascination with Cubism. I designed a place in Devon for Ezra Pound based on his translation of *Confucian Odes* and my love of the tides. All the people who had inspired me were now my clients and artistic allies, and our combined energies pulled me along at a fantastic pace. I continued to invent circumstances that pleased and inspired me, and then I tried to transcribe my dialogues and instructions into design as fully as possible. By the end of the six-week assignment period, I had four fully developed projects. It had been so much fun and so effortlessly creative that I have to admit I felt guilty. The work was well received and I was never completely stuck again. I had learned to trust the wild play that comes easily to the imagination. I had adopted the role of being a devoted reporter of the stories and images that bubbled up freely from the imagination.

I began to refine and evolve my use of visualizations and used this ability to move through the building I imagined or to view it from different angles. Long before drones were in the news, architects developed the ability to see their work from different perspectives. Drawing was the last step of the design chain. I began using a technique in which I visualized myself sitting at a table with the people who inspired me, and I gave them my problems to solve. I have used some variation of this ever since overcoming the block at architecture school. It is a form of inward listening and seeing. When there is no response or I feel myself forcing something, I know it is best not to act. Visualization has become the cornerstone of my creative process.

Everyone has their own way of visualizing. Some people are adept at 'seeing' things in their mind's eye. They can picture whatever they wish, whatever is described to them. Some report not seeing but 'sensing' or feeling the space. Still others might have the capacity to smell the space. It does not really matter what modality works best for you – the key is to follow through and record whatever comes to you through drawings, words and images.

When it comes to visualizing, all scientific evidence points to the value of physical relaxation as a first step. By relaxing or letting go, we make it safe for the ego to take a subordinate role, to briefly surrender its need to be in control – it temporarily surrenders sovereignty in order to allow something new to come into being. For visualization to flourish, the ego needs to be a great impresario, inviting a wonderful cast to the stage. The ego organizes and arranges the environment that supports our creativity, but it allows others to share the stage.

Close your eyes and imagine your dream home. Once you get a sense of the setting, see yourself entering the place. Gently open your eyes and draw what you have imagined. You can also pause the visualization and open your eyes to do a quick sketch. Maybe an element stands out, such as a landscape or a climatic condition. This may register more in your body than in your mind. Sending a somatic signal is just the body's way of processing an intuition. Go with whatever agrees with your own particular sensibility. Think of how we decide what tastes good. We go with what we like. We may like very complex flavours or very simple ones. Creative visualization lets you build space for imagination to flourish.

Guided imagery is a psychological invention that traces its origins back to Jung, who invented the technique so that the clients who had trouble recalling their dreams could access some aspect of their unconscious by listening to a story that was designed to invite unconscious participation. His use of guided imagery rested

on his conviction that the unconscious, when heeded, is a potentially benevolent force and would offer useful hints and guidance for the conscious personality. This technique has its roots in prayer and the desire of human beings to have an experience of being at one with something greater than themselves. When we ask the Creator for help or guidance, we are drawing on resources that are not that dissimilar to the ones used in guided imagery. Over time the idea that we are all potential beneficiaries of the dynamic processes of our psyche became increasingly important to me. When I work with guided imagery, I ask students to write and draw their experiences. After recording these experiences, students form pairs and take turns sharing them with one another. Although our society usually insists that the person speaking is the most important person, this exercise re-balances the equation so that the speaker and listener are equal. It is not a static or simple relationship, so there are times when the gift is in the listening and times when it is in the expressing. When it happens concurrently we experience relating. The listener is tasked with not judging the speaker and most students say it takes some practice to quiet their minds and tune in to the speaker. It is often uncomfortable to maintain steady eye contact because the bonds of trust have not yet been formed. In the beginning, students almost always sit beside one another. After a few classes, a degree of intimacy develops and they sit facing one another.

I draw a simple human figure on the chalkboard with an ear resting on the place of the heart, telling students, 'Listen with your heart, not your brain.' It is truly inspiring to watch what happens with a little practice. The energy in the room is transformed. It is very relaxed, yet very focused. Then the secret emerges: the way you listen to others is the way you listen to yourself. And the way you listen to yourself is the way you listen to your creative voice. This is something that can be honed; through training we can expand our ability to relate not only to others with empathy but to our creative

life with deep receptivity. No one knows when or from where an idea may emerge, so it is best to listen with all our heart to learn what wants to bubble up.

The Physical Model

The physical model has two very different roles. It is a tool for the development of design and a tool for its presentation. These two different jobs may overlap, but I would like to tackle them separately. I am a big believer in using models for design development, during which plan, section, elevation, perspective and axonometric drawings are usually worked on separately and the process of moving back and forth between different kinds of drawings generates ideas and challenges. A physical model allows for the simultaneous development of multiple dimensions of design by simulating the way that we actually experience architecture. Seldom do we walk through a space aware of the various drawings that were used in its description and development. A model is a chance to develop the all-at-once-ness of a building or space. A model is also made by hand and working with our hands connects us to the wisdom and experience of our bodies. By using design, we have an almost stop-frame cinematographic history of the project's development. By using models for design development, we give ourselves a chance to engage in the serious play of design. The constantly changing, tape-and-scrap, tape-and-whatever-is-at-hand model is not the model you make when you know everything. It is the model you make when you don't know anything. It is an experiment that brings multiple perspectives into a single moment. It is the animation of your imagination. Its secret power comes from its willingness to bring the hands and body into an expanded, more democratic approach to design decisions. In particular, it is the untapped wisdom of the body given voice through this approach.

During this process, models are ideal for bringing a sense of materiality to design decisions. A palette of materials used in the model can begin to serve as a test bed for the materiality of the building and the model has the ability to offer a context for the building. Unlike drawings of the project, which are the foundation for instructions about what is to be built, the model can speak precisely to where the building is going to be built. While site analysis is necessary, the immediate insights gathered through a topographic site model are irreplaceable. You can begin to understand how it would be possible to work through most major design decisions through the use of models rather then drawings, and it is interesting to consider how this approach might change the kind of building that will be created.

The presentation model serves a different purpose: it is made for a final presentation in order to sell a project to clients or the community. In the case of a final presentation, it is worth asking what is 'the job to be done'? If the drawings perfectly capture the building, how can the model add to our understanding of the project? Perhaps the model goes back to the big idea and underlines a key intention of the project. Perhaps the model can illustrate a detail or become a conceptual version of the project. In other words, the model provides an opportunity to bring a new voice to the design, something not yet shown through the conventions of drawing. Using a model in this way shows that the student is in full control of his or her project and is consciously trying to expand our understanding of the work.

In the case of architecture, design is a process of trying to perfectly anticipate and describe a building that is not yet built, and will possibly be in a place you have yet to visit. You may have thought about and planned the place. With every day you may get closer,

but until you actually arrive there, everything you do is tentative. Designing is the process of testing our best guesses of what we are trying to create. The design path is not the direct path of knowing. It is more often the path of learning through getting repeatedly lost.

We have a few trusted tools when we set out to design something: plan, section, site-plan elevations and details. These allow us to reference our design against thousands of other designs produced over the course of history. These tools give us a way to ask questions, such as: what is the project like? What is it made of? How does it work? What does it mean? How does it help the community and the planet? These tools allow us to leverage our imagination into physical experience.

As useful and necessary as these drawings, these tools, are, they are not the project itself. They describe parts of the project but they are never what the totality of the project is about. Design is complex because its creative permutations are infinite. Change one thing and you suddenly need to work through a cascade of related factors. The entire system, like changes in a family or ecosystem, can be changed by something that happens inside it or is generated by factors from its outside. Healthy families – those who focus on love rather than on wealth or status in the community – have the flexibility to react positively to change. We need to approach design with a healthy awareness of the inevitability of change in the design system. We must also maintain sight of the engine of the project, the big idea.

The big idea defies deconstruction. It needs to be robust, visionary and compelling. It needs to suggest a job to be done. It is a cross between a Zen koan, a favourite recipe and a good melody. Once it enters your imagination you can't stop playing with it. The sense of wholeness that comes from the big idea rests as much in its ability to simplify as in its ability to recognize the complexity inherent in human environments.

As I have noted, a building is more than a plan or a section. It is not an elevation, structural drawing or site plan, or a material that evokes comfort, amenity or atmosphere. These drawings and elements are all vitally important, but individually they only approximate a small part of the whole. They are necessary approximations, but they are not the experience of the place and they do not conveniently answer the questions of how to begin, or where the meaning of the place or its purpose comes from.

A Hierarchy of Ideas

I have already discussed that having too many ideas is like having none. It is worth repeating here. When you listen to a long list of ideas, the first idea is often at war with the third idea. And the second idea is in danger of sabotaging the fourth. By then, the fifth idea is more than ready to go it alone because it is a new approach entirely. It is truly a list of ideas but in no way does it form a compelling narrative. This list of ideas often causes a disconnect between the words and the drawings, limiting what can be created. It is an example of how desire can get in the way of what we want. Accepting the hierarchy of ideas brings an organizing element to our ideas; when there is a simple hierarchy of ideas, there is a better chance for design traction and deeper development. There is an old Yiddish proverb that wisely states, 'When there is too much something is missing.' I find that the 'Big Idea' of a project will, over time, naturally give an order to your ideas.

AN ELDERLY AND well-travelled architect once told me about working in a small architects' office in Denmark after the Second World War. Each architect there had several desks and each desk was used for a different creative activity. At one desk, he would

work on the elevation and at another he would make a model. At a third desk he would draw the plans. He explained this as a process of physically getting up and moving to each new perspective on the project. Not every studio has this amount of space, but I think the principle is rock solid.

I have often seen students who have a great idea about the plan of a project spend day after day evolving the project in plan until a very fine plan takes shape. Driven by a desire for a perfect plan, they run out of time and are not able to complete any other drawings. Sometimes the obsession takes such a hold that it is only when they are in the middle of presenting their work at the end of the term that they realize that they have left out many of the drawings required to understand the project.

By moving through all the different views of the project, you will never get stuck and, in doing so, you also give yourself the very real chance to discover meaningful interdependencies between plan, section, elevation and models. The methodology of simultaneously developing plan, section, detail, elevation and rendering brings you closer to the way that every built environment is experienced. Overlapping experiences with multiple origins and multiple elements provide a rich design process. These different views or media have their origins in explaining construction to a builder and are probably going to be the conventions used by architects well into the foreseeable future. They offer no limits or restrictions to creativity. In fact, the wise designer uses these conventions to invite flow, depth and invention into the design process.

5

Getting Stuck

EARLY IN MY postgraduate education in psychology, I was feeling completely overwhelmed, pulled in all directions without any promising destination. I took refuge in the reading room of a small library in midtown Manhattan that specialized in the works of Carl Jung, and what started as research for an essay became something transformative. Here, alone with his remarkable books, I found moments of balance and clarity that became forever tied to my study of Jung's work. I was still uncertain how to proceed, however, when a friend suggested that I visit an old Scottish woman known for her psychic abilities and energy-based healings, who had a reputation as a gifted healer. I was not exactly clear on how she worked or what exactly she did, but one of the gifts of being lost is that you find yourself willing to try new things. I was at a turning point, with no good sense of how to go forward and nothing to lose, so I called her. She answered the phone with a sing-song Scottish accent and we made arrangements for me to come to her home for a healing. When I arrived at the appointed hour, I was surprised to find myself in front of an unremarkable suburban bungalow. A tiny woman with white hair and lively eyes opened the door, welcomed me warmly, and asked me to wait in a small sitting room that had obviously once been a bedroom. A few minutes later, she invited me into her treatment room in which the walls were decorated with half a dozen portraits of healers from across the globe. She explained to me later that these were her guides and they did the healing work. She was merely their instrument. She had experienced their powers in her visions for many years

and had described their faces to an artist who had painted the portraits. I felt as though I were among an ancient council of elders and when I close my eyes I can see still see some of their faces.

We sat facing one another and she began the healing by saying a prayer, in which she asked for help from her guides, pledging to be their humble servant, asking for their love, guidance and light, formally inviting them to help her. After a few seconds of silence she began to take several very deep breaths and then fell into a trance. I felt my eyes shut and then she began to speak. Her voice was now much deeper, almost raspy, and she spoke with unexpected power and authority. She began by telling me about some patterns that governed my behaviour towards myself and explained where this had come from. Then she talked about my recent experiences in detail, although I had not told her a word about myself. I was surprised when she went on to discuss my childhood and several events that had shaped my life. The room was crackling with energy. Before I could figure out how she knew any of this, she paused and asked how she could be of service to me. While my head was still spinning from her insights, I told her that I was thinking of quitting the postgraduate course and gave my reasons. When I finished, she said with total conviction, 'You go back there. And get your degree. You do not quit. You finish what you start!' She clapped her hands for emphasis after each sentence. Her determination and positive energy were outrageous and completely infectious. I wanted that certainty. Her words were like fire. 'You go back there and finish!' It was audacious and the opposite to what I was planning. But I knew that she was right. I hadn't believed in myself enough to even attempt such a thought. My plan had been to give up. She knew it and was having none of it. I suddenly began to feel happy. She

saw my mood change and repeated her instructions, telling me that my ancestors who had recently passed were going to help me. I suddenly felt as though my sense of victimization had evaporated, and things were going to change.

The healer went on to give me example after example from my own life that pointed to how this withdrawing was no longer necessary. How she knew what she described, I have no idea. She was very direct in her choice of words and I found myself trusting her. Soon my healing experience came to an end. She gave thanks to the creator, whom she called the heavenly parent. Less than an hour had passed. I thanked her and left. As I got back into my car and looked down the deserted suburban street, I began making preparations for the journey that lay ahead.

A few days later I found myself at the library looking up the names of ships in the British navy. *Steadfast. Defiant. Resolute. Victory.* For some reason this led me to the history of wrestling and I felt drawn to learn about its origins. I cannot explain the sudden urgency that overcame me. I was searching for role models who could teach me how to fight and I needed to learn what wrestling was all about. I researched the labours of Hercules. Some authors said that each of the twelve labours represented a particular psychological lesson. His teacher had warned Hercules of the difficulties he would need to overcome during these trials and would secretly give him a symbolic key to victory. He, too, was learning how to fight. I recalled the Scottish healer telling me that life was a classroom meant for learning important lessons. As usual, from the psychological point of view, the most dangerous enemy is often found within.

My quest led me to interpretations of the Old Testament story of Jacob wrestling with an angel. Scholars and sages asked why it would take an angel all night to defeat a mere human being. Why was the fight not decided right away? Commentators seized

on this contradiction to point out that the angel did not want to win the fight, but rather wanted to find out if Jacob was willing to wrestle all night. And when he showed himself willing to wrestle until dawn, the angel ended the fight and changed Jacob's name to 'one who wrestles', or Israel. For the next five years I carried with me Gustave Doré's image of Jacob and the angel wrestling. I keep a reproduction of this image in my office. I even put it on my business card. If I ever get a tattoo, this would be the image. I decided to devote myself to wrestling until the first light of dawn. I would complete the degree in psychology in order to learn how to wrestle. It turned out to be an incredible challenge that led me to meet my wife and remake my career. Rabbi Abraham Heschel said, 'Show me someone with no problems and I will show you an idiot.' I think that he meant that life is not simple and was never meant to be simple. We need to face difficulties to become whole; they are in fact a special kind of gift and medicine. As Jung said, we cannot solve problems, we can only outgrow them psychologically. The idea that wrestling was not a form of entertainment but an instruction about life became my North Star.

As designers I think that we can actually learn that creative challenges have a profound purpose. They are meant to tell us when it is time to go deeper. They are calls to have more courage and to not be afraid. The purpose of all obstacles is to bring more depth and greater wisdom to what we are doing. I see obstacles as performing a unique role in the creative process: that of bringing meaning and, in the case of architecture, perhaps even giving the built world its soul.

The Purpose of Getting Stuck

No one chooses to get stuck, but in any creative process we are going to reach dead-ends and roadblocks; we are going to go

down good roads that gradually turn to dust. We all have a fear of ideas drying up or getting lost during a creative journey. But why should we be surprised by something that happens with some regularity? It is as though the ego believes that it is in control of the creative process and has no ability to remember ever failing or getting stuck. It just cannot abide the thought of imperfection. But getting stuck is inevitable and necessary because creative work is not rational or programmable. If we knew exactly what the outcome would be, it would not qualify as creative work. If we were willing to understand creativity as a way of not only responding to challenges but learning about ourselves, we might see that getting stuck can be very valuable. It is an efficient and economic way for the unconscious to speak to us, commenting on our current approaches and beliefs — a built-in mechanism that signals a time for reflection. Becoming stuck means that our work is about to deepen and if we allow its healing powers to work, we will learn a valuable lesson about ourselves.

Our relationship to difficulty has to be one of love. When I was a student, what would set me back was not just getting stuck, but also my anger and frustration at the situation. My own reactions obscured my ability to see what to do. More and more, I think that the best thing to do in these situations is nothing. When we get stuck we have been called to reflect. I do not mean that you should go on holiday, but taking a walk or a deep breath can be more effective then stewing. Even disappointment has a purpose. Learning how to fight for what we want to create is really important. Learning how to fight for its own sake is not the same as knowing what to fight for.

Terry

TERRY, THE TOYOTA service manager, had always been friendly
and helpful. As we chatted one day about our favourite cars,
I mentioned an older Camry model that I used to own. It turned
out that he had owned the same model. We discussed its many
merits – as far as we could tell, the car did not have a single flaw.
Our common appreciation for the car solidified our relationship;
nothing brings men together like agreed-upon praise or blame of
a machine. We suddenly trusted one another like brothers. Our
values were similar. We saw the world the same way; our choice
of cars proved that.

I spoke to Terry every time I went to get my car serviced over
the course of three years, but our conversations never moved
beyond professional car dialogue. Out of the blue, Tony surprised
me one day by bringing up something personal. He told me that
while he was driving in Manhattan, on his recent trip to New York
City, he had lost his temper with his children, who were arguing
in the backseat. He had shouted at them, he said, because their
constant arguing was making it hard for him concentrate on
driving. Sheepishly, he told me that he had later apologized
to them for losing his temper.

The dealership we were sitting in was a large, brightly lit room,
painted white with a big TV on the wall. Terry and I were facing
one another across a grey plastic desk. No one else was waiting for
a service, but in the distance I could hear mechanics talking and
tools clanging. When I asked him if his kids had enjoyed the trip
he suddenly looked sad and said no. They hadn't wanted to go. At
that point Terry started to tell me about his relationship with his
son. At the start of the school year, he had told his son that he
must obtain at least 80 per cent on all his exams or he would lose
his time on the Internet. 'If you don't do well, you can't play games

with your friends,' he had said. He felt that doing this was right because getting a good education was important. He had arranged for maths and science tutorials for his son every weekend, but none of this help was having the desired effect. It was becoming clear that just the opposite was happening. His son was doing poorly in school and told his father that he did not care whether he had Internet access. The son had tuned his father out. Terry said that he was not angry; he was sad. He could not explain what had caused his relationship with his son, whom he obviously loved, to sour. Terry said his son was disrespecting him and he did not know why, and that he would never have spoken to his father the way his son spoke to him. I commiserated, telling him that my father was like a god to me and I always obeyed him. We both laughed. At this point I could feel the frustration of Terry and his son. Disciplining a teenager is never easy. I hesitated for a moment before gently asking, 'What music does your son like?' Terry was surprised by the question and said he didn't know. 'What about games?' I asked, 'What does he like to play? What are his favourite TV shows? Does he watch basketball?' Terry finally admitted that he did not know any of these things. He looked at me, totally bewildered. Obviously these were questions that he had never been asked by his father. For him, fathers were in charge but rarely in touch.

Nearly half an hour had passed and our business was usually finished in minutes. Terry looked vulnerable and less angry. We both stood up and walked over to my car. An awkward silence settled over us until Tony removed the work order from under the windshield wiper and handed me a free courtesy umbrella. We shook hands and parted. Terry wanted to fix his son's problem by getting him extra tutoring, but the tutoring had no chance of reaching the real problem. Terry's son needed his father's attention and affection. I have found that in my approach towards creative work and in the way I work with others, frustrations and disagreements often

signal an opportunity to learn something new. Though it seems counterintuitive, compassion helps to solve problems.

No one consciously chooses to get stuck, but we do; it is inevitable that at some point and possibly repeatedly we will find ourselves lost or frozen during a creative project. Instead of trying to get rid of the creative project, try to have a better relationship by changing your inner attitude to it.

Getting stuck can be a terrible blow, because it teaches us that we are not perfect, that we have less power and less control than we thought. The beauty of this is that when we let go and accept our difficulties we open the door to new creative ideas. If getting stuck teaches us that we need to go deeper, then it is the greatest gift of the creative process. Getting stuck is extremely important in the ecology of creativity. While it brings frustration and sometimes confusion, it also means we need a new point of view and a new understanding – this reboot is the only way that our unconscious can present that new point of view.

If you have any experience of driving in winter, you know your vehicle can sometimes get stuck when you push too hard on the accelerator. What works to move the car in summer will fail in the winter. When you get stuck in snow and step on the accelerator, you will often spin your tyres, turn snow into ice, and create a slick, frozen rut of which you will never be able to power your way out. The best way to get out is to take your foot off the pedal. Easier said than done. I know it seems counter-intuitive and illogical to stop trying when we want to make a change. But when I am stuck creatively, even though I may feel desperate, I know that I do not need ideas, but a clear mind. Getting stuck is usually such an emotional experience that an individual loses the ability to relate to the problem. This is not always the ideal time to introduce more ideas.

In fact, when your car gets stuck in snow you sometimes have to go backwards before you can go forwards. You may need to go back and review the process or the decisions that have been made. When were you last feeling good about what you were doing? You may have driven yourself into a state of distraction and failed to notice that you lost traction some time ago. As old-time drivers used to say, when you drive in winter conditions you need to imagine an egg between your foot and the accelerator. For designers, this means we need to apply a special sensitivity; our creative drive needs a sensitive driver.

The first thing to do when you get stuck is to know it is part of the creative process. I think of getting stuck as a message that you need to pause. Something in your approach was perhaps not helpful. You may need to recalibrate your approach. You may have been pushing too hard and become overwhelmed. You may have lost connection with your initial inspiration. I am particularly drawn to exploring the role of difficulty in the creative process because it has so often helped me to find my creative footing. As you gain experience, you are less likely to feel devastated, but getting stuck can still rattle you and undermine your confidence. Many students who have been able to explore their way through the difficulty have been able to deepen and redefine their work.

How do we get unstuck? Do something different. Let the creative part of yourself know that you are going to take a break. This way you can maintain the relationship to your creative spirit and leave on good terms. You will be back, but you are gently and nonviolently choosing to step down for now. Use this time to reflect on the creative journey you have taken so far: what was positive? Were there warning signs that you ignored? Go surfing or dancing. Play. Take a nap. Do anything that brings you into a relaxed flow experience. Change your mental focus. Let your body have more say in the process.

Sometimes when I go to a restaurant I can be so overwhelmed by all the choices on the menu that I do not know what to order. No matter how often I look at the various options, nothing stands out. Then I realize that I don't know what I want. So I close the menu and listen for a voice within me to suggest what I want, then go back and look for it on the menu. Getting stuck can sometimes mean we have lost track of what we want to create. We need to find it again.

Running away or ignoring the fact that we are stuck sends a strong signal to your unconscious that you have no interest in collaborating with it. In my experience, this always results in the unconscious refusing to offer its assistance. Cutting yourself off from the helping power of the unconscious ends the creative process. The unconscious has evolved over millennia to offer its compensatory message to expand consciousness. Our job is to make sure that the ego is willing to connect with and learn from what arises from the unconscious. This communication can take many forms. One is through the symbolic language of dreams. I once had a dream that I was driving a bus too fast and understood it to mean that I was probably not allowing enough time for the class to process the material I was teaching. The next day I changed my approach and slowed everything down, and the class immediately slipped back into sync. The unconscious can speak through physical symptoms as well. I have held on to negative thoughts that gave me headaches or stomach aches. Those are ideas I choose not to follow. The unconscious can also communicate through design difficulty, such as getting stuck or not liking what I am doing.

If we honestly look at the relationship we have with an obstacle, it will reveal what we need to do to move forward. I was preparing a studio syllabus and the dean suggested that I take a particular approach. I agreed to his suggestion too quickly and soon realized

that I had made a mistake, because I immediately began to feel lost and confused. It would have been better to say, 'thanks for the suggestion . . . I'll think about it.' Instead I agreed to something that did not resonate with me and I ended up getting stuck because I was angry with myself. With this seemingly modest realization, everything shifted and a great shadow lifted off me. I moved forward and found the thread that put me back on track. The most difficult thing for many of us is to admit that we do not have all the answers. That we do not know everything. The moment that we can accept failure is the moment that we can begin again, always slightly wiser.

A Masterclass in Music

I DO NOT play the piano, but I jumped at the chance to attend a masterclass for piano students. An audience of perhaps thirty people sat in the small rehearsal hall at the Royal Conservatory of Music in Toronto. It had been recently refurbished but still retained its no-nonsense, barn-like charm. Most of the people in the audience were obviously music students and a few, like me, appeared to be curious music lovers.

I could not help but notice the student sitting in front of me was broad-shouldered and built like a giant and was almost too big for his seat. The maestro arrived, was introduced, and sat down in the front row of the hall. The professor welcomed us all and then called on the hulking student slouching in the chair in front of me. He unfolded himself from his seat and loped onto the stage, pausing to nod awkwardly at the maestro as he passed him. He sat still at the piano for a breath or two and then launched into a furious piano sonata by Beethoven. After a remarkable fifteen minutes, he came to a crashing conclusion. I wanted to cheer. The audience applauded warmly. The maestro got up and pulled up a chair beside the student at the piano. The teacher complimented the student on his playing

and then made a surprising request. He asked the young performer
to let his arms hang loosely at his sides. 'Just let your arms hang like
this,' he said and demonstrated. The student followed the maestro's
example and let his arms hang freely, his hands gently flapping in
a way that looked very relaxing. The room was very quiet. No one
knew where this experiment was heading. The teacher continued to
encourage the student to let his shoulders, arms, hands and fingers
relax. The piano lesson began with the body, not the music. None of
us really understood what the maestro knew – that the body would
be a key collaborator in creating musical expression. The maestro
was showing that the arms were conduits of creative energy and
needed to be open to the expression that was coming from the
young performer's heart and mind. The student was being asked
to make sure that his shoulders, elbows, arms and hands were not
holding him back from expressing what the music needed him to
say. There had been no discussion of the music, only this request to
refocus on making sure the body was more consciously included in
the process of making music.

After a few more minutes of guiding this body-centred
meditation, the maestro asked the student to bring his hands
to the keys with a new awareness and play a particular sequence
from the composition. It was obvious to everyone that the music
sounded much more fulsome, rich and present. This became
the theme of the fifty-minute lesson. The maestro prodded the
student to articulate what he was feeling and then, when the
student was able to answer with more clarity, the maestro asked
him to replay the section. His feelings, manifested in his body,
were being given a chance to speak. Even though the brain sits on
top of the body, that does not mean that it is superior; it is only
one part of the whole body. The student was noticeably less stiff
now and was more involved in the moment-to-moment emotional
life of the composition. It was a simple yet powerful lesson. Not

because the music had become more rich and meaningful, but because his entry point had been the lesson that, to achieve this, the musician had to accept the wisdom of his body. If his body was too tight, nothing could be expressed; if it was too loose, nothing had meaning.

Just as the body is very involved in making music, so, too, is it very involved in listening to design. Finding the right balance – not too tight, not too loose – is a fundamental instruction for everything from music to meditation. The body is always waiting patiently to be asked to contribute to the creative process. A stomach ache sometimes lets you know that you cannot stomach an idea. A headache might be nudging you to look at whether your thinking has become negative. The need for rest might be a call to step away from your work, close your eyes and begin to imagine things anew. The complex ecosystem of creativity includes the body and, for some, the body is the most trustworthy source of insight.

Another way to get back on track after being stuck is to sit down with a trusted friend and tell the story of the project. Share all the feelings that you have had about the project – the highs and lows, worries, doubts, successes and confusions that it has engendered in you. Just expressing these things and being heard will often allow you to re-engage with the project.

All of this begs the question: if getting stuck is so useful, why can we not summon it? The reason is, as Jung said, that the ego has sovereignty over consciousness, while the unconscious is autonomous. We cannot summon getting stuck, but having a compassionate regard for the messages we receive from the unconscious will ensure that our inner navigational system is a powerful ally.

Self-criticism

One day, shortly before a major studio deadline, it seemed as though every student was having a meltdown. The pressure was too much. One was in tears and another had emailed me to say that he had never experienced so much anxiety. He could neither sleep nor think and now he was unable to create. Another student was unable to design because he had suddenly and unexpectedly broken up with his girlfriend. He was devastated and unable to work, he told me, and was worried about being able to complete his project by the deadline.

I met with the student who had emailed me about his anxiety. He looked exhausted. He began by explaining that he had started his project by analysing conditions relating the programme to the site. Everything he said sounded perfectly reasonable, but for some reason he had frozen when he had tried to move his design forward. Every time he tried and failed, his self-criticism increased. This cycle had repeated so many times that his creative energy had understandably wilted in the face of his now formidable self-criticism. He found himself saying things like, 'I shouldn't be having these problems. I should be further ahead.' He would compare himself to his colleagues, thinking, 'Why am I so untalented?' There was no good ground to stand on. Looking at his work, you could see that he had all the ingredients he needed to succeed. He explained himself very well and was very skilled at drawing. It became clear that what was stopping him was his thinking. He was amplifying every little obstacle into something enormous. His psychological problem was causing his architectural problem. The way he talked to himself was destructive: he was in the grip of, and totally possessed by, his negative thinking.

The first thing I wanted to do was shift his relationship to his thinking. I felt that if he could stop the negativity for a moment,

something creative would drop into place and his sails would fill with air. Starting with the question that every young architect seems to dread, I asked him who his favourite architect was. He did not want to commit to an answer at first, but I would not back down and eventually he gave me the name of someone whose work he admired.

I then asked him what inspired him about this architect's work. After a brief pause he gave a very clear answer: he liked the way that the architect's buildings related to the landscape, the rich materiality, and the way spaces inside and outside the buildings were intertwined. When I asked him if he could imagine working for this architect, he said that it would be his dream job. So I suggested that he take a moment to do just that, imagine that he was working for this architect right then. What did it feel like to have his dream job? I asked him to further imagine that his favourite architect was actually working on resolving the project that this student was working on. All he had to do was explain the problems he was facing to his boss. The student looked at me and smiled. 'All you have to do,' I said, 'is pretend that you work for him. Every time you feel the least bit stuck, ask yourself what he would do. Bring the inspiring aspects of his work directly into the resolution of your project.' I was hoping that this might help him develop a more positive feeling towards his own work and perhaps generate some momentum and creative flow. His attitude seemed to become slightly more positive.

The student began applying his favourite qualities of the architect to his project. He saw that he had left out of his project the kinds of things that had inspired him in the other designer's work. He quickly sketched a revised version of his plan. I asked him to draw a vignette of the new condition, then a section. He had a model and we spent a few minutes updating it to include the new changes. Within twenty minutes, a new project built on

the previous one was taking form. I left him to test out what we had discussed and then returned twice later in the day to see how he was doing. The first time I returned he still appeared to be tentative and undermined by his habitual negative thought patterns so I responded with a lot of positive encouragement. Later in the afternoon I came back to his desk and what he showed me had wonderful character. He had somehow cracked the code of his project and found his enthusiasm and confidence. The project was moving forward creatively. He managed to get it done in time and he actually liked what he had created. The final project contained a few design scars from its tumultuous journey, but it also had a strength and character that were undeniable.

A few months later the same student came to see me with an interesting problem. He had lost interest again, this time in his postgraduate work. He had put together a proposal that made sense but did not really move him. It was more or less something he had done to please his somewhat aggressive and pompous teacher. That was a problem, but the greater problem from my point of view was that he had completely lost track of what he wanted to do. When I asked him what he wanted to do, he surprised me by answering that he wanted to work with his hands. He wanted to make things. It turned out that he came from a family of carpenters and his brothers were all in the trade. He had always enjoyed making things and described a few things that he had made, many of which sounded wonderful. 'Are any of these projects in your portfolio?' I asked him. He said no. He did not include them because he did not really think much of them. But they were wonderful projects and they were exactly what he liked to do.

'So what do you want to make?' He didn't know. But he had taken a giant step forward: he knew that he wanted to work with his hands. And he knew that he was finally ready to begin

again. He suddenly looked stronger and happier. He had his creative spirit back. The winter holiday was coming up and he would have time to visit a few places that he loved before he began his studies again. His connection to the land was very important to him. I was confident that he had found the energy to do what inspired him. When you abandon what you love, you lose your connection to yourself and your energies falter. This is not simply the loss of an idea but a loss of connection to one's self. One of the tragic consequences of our ignoring these kinds of difficulties is that everyone feels that they are alone with their suffering. It is not unusual to have many students in a class going through emotional stresses, but rarely is there a safe venue for peer-processing of these experiences.

The Rule of Force

Long before we learn to design buildings, we have already acquired many years of experience in how to solve problems. This experience comes from ordinary challenges, such as opening the lid of a stubborn jar of tomato sauce by firmly knocking the rim of the jar on the countertop; if that fails, try heat; and if that does not work, repeat the same process but with more force. The methodology is always the same. Apply as much force as is necessary without breaking the jar. In the material world, the use of force stands at the head of the queue when facing a problem. It is not a coincidence that the largest hammer you can buy is called the Persuader.

As designers, when we create, we are playing with ideas and qualities that are in a pre-material form. An idea is real but has no substance; the laws of physics that work in the material world will never reach the inner world of creativity, because gravity, friction and time do not apply there. So we are mistaken when we relate to an idea as though it will respond positively to being attacked. This energy, however easy it may be to mobilize, is essentially wasted.

In the inner world like attracts like, so if you increase force in order to solve a problem, the desired result will be pushed away. Effort, strength and determination are still necessary, but they need to be used skilfully. When faced with a creative problem, aggression is less helpful than affection. You need to be determined but not violent. You learn this very quickly if you try to meditate. Forcing yourself to watch your breathing without any kindness quickly becomes a headache.

Our aggressive approach to problem-solving can be found on every level, with predictable results. It is present in the way we 'attack' the housing problem, the transit problem and the pollution problem. The Dalai Lama has said that war is an outdated response to our problems, yet we unconsciously continue to use this approach

with little gain. By using force, we reduce our options. It is an anti-creative and non-sustainable approach. That is why stepping back and doing nothing is often far more useful than attacking the problem. Others may label you as lazy but a strong case can always be made for creating conditions where the creative spirit can flourish. It takes courage to take a break when everyone around you is working without a pause. Sometimes people work unceasingly because they are afraid of having to experience their thoughts. Pausing can allow us to reconnect to our inner selves and restore a sense of flow. In a very practical way the pause allows us to bring kindness to the emotions that may be frustrating or blocking us, such as fear or anger.

FOR THE LAST two years, I have been carving a large wooden bowl the size and shape of a big salmon. The first year I worked on the shape and began to thin the sides of the vessel, but had to stop because I lost my sense of how thin to make the side walls. I blamed my tools and the slab of wood and did nothing. Months later I looked at the bowl and realized that there was no problem and resumed carving out the sides. I removed quite a bit of material and then had to stop because I had lost my way again. A few months passed and I went back to the bowl. All the obstacles and frustrations were gone. Now I am close to being finished. The problems were never with the tools or the material itself. The problems were mine. They were psychological and once I gave them space, my sense of flow returned. Over time the bowl has acquired something I could never have planned: a sense of time. Unfortunately in the so-called real world, time and deadlines are rarely this flexible, but the lessons learned in the inner world are quickly transferable and can have immediate impact.

A wise friend passed along the following mantra: Let Go. Set Free. Judge Not. That covers just about everything I can think of to prime your mind and body to create. I keep this slogan in front of me when I work. Letting go sends a signal that you are not afraid to release old ideas and invite new possibilities. Setting free brings goodwill to letting go. Letting go can be deliberately practised by mindfully dropping unwanted drawings into the rubbish bin. Judging not means not judging yourself, your ideas or others, and brings you into a more equal relationship with whatever you are doing. When you can let go of your desire to solve the problem, you may actually be granted a chance to see the problem as it is, without your opinions and beliefs masking or distorting the issues. Your ambition is still there, but it now includes the positive feelings necessary to bring yourself into a more meaningful relationship with your design. So the next time you are stuck, consider using not force but tenderness. How might tenderness improve your relationship to the problem and shift your approach to its resolution? How might benevolence and affection widen your understanding of a situation and invite new resources to the questions you are facing?

Deadlines are a great time to watch what happens when you try and force the design process. The pressures and panic surrounding a deadline can be immense, but under the influence of fear it is difficult to act or think clearly. A deadline may narrow our focus in order to concentrate, but a narrow focus is not a creative state. It is a fear response. Our motivation shifts from creating to avoiding catastrophe. From the point of view of learning about our minds, the real value of a deadline is that it shows us the influence of fear on creative work.

The best advice concerning focus comes from a well-known meditation instruction in which the mind is compared to a stringed instrument. If it is tuned too tightly, the string will break; if it is tuned too loosely, no sound comes out. The best results come when the

string is neither too tight nor too loose. Ask yourself, where am I on this spectrum?

A HIGH-SCHOOL TEACHER taught me a method for making decisions that involved listing the pros and cons of any decision. You simply filled in a spreadsheet and it would magically tip your decision to one side or another. I never found the technique helpful. Now whenever an answer is not obvious, I try not to act. I wait until I get a clear sense of the direction to take before initiating an action. Sometimes I sleep on it and check in the morning to see what feels right. Not every decision is simple. There are many shades of grey. It is very important to develop a deep trust in the process of creating because the 'eureka moment' is outside of our command. Determination, resolve and real affection for our work often decide the matter and these are things we can learn to control.

What technology is to the material world, psychology is to the human world. Both can make our lives better. Technology is easier to see and impresses us with its effortless, almost magical performance. Signals received on earth from an interstellar unmanned probe to Mars are truly remarkable. Meanwhile psychology asks us to accept the existence of constructs such as the unconscious mind, the ego and the psyche – things that no human being can see or touch.

Technology makes our lives better in practical ways that seem easy to measure and can be instantly appreciated. Psychology does so in ways that are not only difficult to measure but may take considerably longer to be appreciated. Psychological reality is as much a fact as, but is less valued than, the outer reality. It is aimed at understanding the human responses and actions that our senses

have no immediate way of identifying. Why did I choose to trust that person? What caused me to react so emotionally to that person, film or song? Why is love so baffling? Why do I always feel negative when I have to present my work? Data may help us solve certain kinds of problems, but it may offer no insight into chronic emotional problems that arise from the unconscious. This is particularly clear when you watch groups function. What we do not understand about ourselves becomes multiplied in group settings and can make cooperation impossible.

Psychology traditionally concerned itself with pathology. It began stiffly, uncertain of its usefulness. As it becomes more and more absorbed into modern society, it has begun to expand its domain from the world of pathology to the world of well-being. Instead of neglecting mental health, sports psychologists, life coaches and career counsellors have shifted their focus to helping individuals build resilient and positive connections to their desire for a better life. The widespread acceptance of psychology is not the result of advertising, but word of mouth: from TV talk shows and self-help books to individuals sharing their stories of suffering, heroism and well-being. While technological inventions seem to tie us to all forms of media and communication, leading us into endless new frontiers, an equally impressive expansion of human issues has been demanding our attention. In the last two hundred years child labour and slavery have been abolished, in most of the world. Long-standing imbalances in social justice and gender inequality have been greatly reduced. More and more children are being educated. Resources for better health care have expanded to parts of the world never before served. I believe that this greater inclusivity, basic affection and respect for human beings show the true value of our increased acceptance of the reality of psychological experience.

The shortcomings of a technologically dependent world are most noticeable when stimulation ends. Our devices can do many

things, but they cannot act as mirrors showing us who and where we are in the long journey to becoming human. Psychology is precisely such a mirror. Unlike technology, psychology can never be turned off. Even if they are denied, insights from psychological awareness wait patiently for our eventual willingness to listen and to grow from them. Given the emotional suffering and confusion that visits all of our lives from time to time, the only real surprise is that we refuse to give them the attention they deserve. Our psychological experiences are real and have the potential to make our lives better. I would never argue we need less technology but I would say we need more psychological education. Psychology is not just about relieving suffering, but about creating meaning. If designers are creating places where we can feel at home, it needs to be acknowledged that being a modern human includes having a level of psychological awareness that is unique to the modern era.

We think that design takes place at the computer or at the desk in the studio but design always happens in the mind and body. In the same way that we may think we are making decisions about what to buy in a shop, in truth the purchase always happens first in our minds and bodies. Even when we shop online, what brings us to a particular website is a thought, a feeling or a desire; the clicking of the button that activates the purchase and seems so concrete is long prefigured by inner calculations and negotiations. The mind is an environment that we know very little about, but it determines many of our likes and dislikes. With all its neural networks, the mind is not just concerned with data and information, but is also very busy wrestling with emotions, beliefs, habits, views and opinions. The brain is as much the scene of emotional as it is of rational events. We have increasingly begun to talk about the brain as a computer, using terms such as 'neural networks' to discuss how it functions.

But in doing so we cannot forget that these networks apply equally to emotions and thoughts, habits and memories. I have long been interested in getting to know the relationship between our minds and our creative decision-making. It is clear that when called upon, the mind generally provides reliable and effective service in support of our wishes. But creativity is not a logical, computer-like operation of the mind. For all the talk about materials, sites and programmes, there are also anxieties, worries and uncertainties that influence our intentions and ambitions. What is happening when we want to create but instead of being able to move forward we are filled with worry? What is happening when our emotional minds, creative brains or cognitive brains are not able to cooperate with each other? At that point we suddenly discover that the mind is not the servant we expect it to be. It seems to have autonomy, and we are flummoxed. It is like living in a house and suddenly having no idea where to find the things that you use all the time. We are strangers to the workings of our emotional, cognitive and creative brain.

Every designer knows that the internal dialogue that accompanies a creative project is rarely a singular, sustained, focused inquiry. Even if we are alone in the studio, our inner world is teeming with constant interruptions, disjointed thoughts, opinions and emotions. When you come into a design studio, most students are working on computers, listening to their music. Everyone is one click away from an entirely different world. The level of convenience is remarkable. But we offer no training in how to focus our attention, settle our emotions or nurture creative flow states. Our ordinary everyday states of mind can be monopolized by worries, anxieties and frustrations not because they are inevitable but because we have never been taught how to train ourselves to relate to these states, and therefore transform them in useful ways. If we had a

device that could measure the inner world of thoughts and feelings, the number of states per day would be huge. The untrained mind is constantly busy but the number of thoughts devoted to events actually taking place in the present moment is small and far outweighed by worries about the past and concerns about the future. A recent study titled 'Track Your Happiness' illustrated this in an elegant way. An app canvassed thousands of users by asking what they were doing and what they were thinking about. The results showed that most of the time people are thinking about the past or worrying about the future. Less of our time is actually spent being engaged in the present moment. Our design curriculum doesn't ignore the material sciences but does ignore the fundamental inner sciences and the explanations for human behaviour found in psychology.

I BEGAN TEACHING basic meditation to postgraduate architecture students to give them a chance to experience their own minds. We did short meditation exercises using the classic approach of the four postures: a few minutes each sitting, standing, walking and lying down. We began with sitting because it is easiest and then moved into a standing posture. What surprised students the most was the experience of walking meditation. We were moving but we were not really trying to get anywhere. By the time everyone had finished the lying-down posture and returned to sitting, the atmosphere in the room had dramatically shifted. We had meditated for thirty minutes. Studies are showing that even a few minutes of basic mindfulness meditation has a positive impact on physical and emotional health. Just as computers have revolutionized many aspects of our lives, so, too, will mindfulness training. The perfect place to start will be in our schools.

Worry

How does a worried mind affect the design of a building? Is it as simple as projecting our worries into our work? Or is it more subtle than that? When worry and doubt monopolize our attention, they reduce the time we have available to work creatively. And reducing our ability to be really present affects the amount of time we spend creatively focusing on design. If, for example, you find yourself always worrying whether people will like your work, you are probably spending less time developing it. Even when you produce something, you may find yourself undermining the good you have created.

It is not a stretch to say that we can sabotage our own wishes to be successful by allowing worries and anxiety to dominate our thinking. Worry is like the little cousin of getting stuck. Less acute but more chronic. A regular meditation practice loosens the grip that emotional worries and anxieties have on us. I have also found that one of the great benefits of working with your hands and using a more sense-based approach to design is that the senses always bring us into the present. The smell of coffee exists as a memory or anticipation but the actual experience of tasting can happen only in the present. The long journey to becoming a more creative, confident and capable designer asks us to really appreciate and enjoy the gifts of the imagination.

WE WERE A group, sitting together on the shores of a pristine wilderness, that had been brought together by a desire to go on a canoe trip in a remote corner of northern Ontario. I was really looking forward to getting started, but before we could set out, the trip leader gave us an assignment. He asked each of us to paddle our canoes out to the middle of the lake, and when he thought we were far enough from the shore, he shouted, 'Ok, now sink your

canoes.' At first, most of us were hesitant, but once we accepted that we were actually trying to sink the canoe we had a great time. We rocked back and forth until water started pouring in over the gunnels and the canoes took on enough water to capsize and we found ourselves floating free in the clear cold water. The leader then paddled out and showed us how to get back into a dry, righted canoe. The entire initiation took about half an hour but by the time he was finished we had all mastered the art of tipping and getting safely back into a canoe. There was real wisdom in his approach. Over the next two weeks, in spite of travelling through difficult and stormy waters, we had the confidence to handle the conditions. Our fear of tipping during the trip was undone when he had us face our fears before we began.

When you are stuck, waylaid, feel defeated or afraid of failing, rather than avoidance, try to accept the problem. Consciousness changes things. Acceptance does not mean giving up. By acknowledging difficulties you will be strengthened and be able to recall other experiences in which you were able to overcome adversity. Without acknowledging the problem, how can you adapt or change your approach? If you are in the right mood, try to have some fun by undertaking a brief exercise that will make your project worse, more outlandish and less likable.

If you are overly consumed by persistent worry or anxieties try seeking out a good listener. Sharing these feelings in the present and experiencing the genuine relief of being heard can liberate you from repetitive and often negative thought patterns. You will know if you have been heard because you will feel able to re-engage in creative work. Flow will return and you will feel newly empowered. We live in a time where help for anxiety, depression and excessive worry has never been more available. For centuries, trauma was

uncontested and its victims lived lives of disassociation, illness and fear. Fortunately, those days are ending. This healing is making itself felt in the world as more and more stories of victims find their way into the news, films and popular culture. This is not a sign of a world gone mad. This is evidence of the growing force of empathy and compassion. As the world looks in the mirror and moves towards well-being, everyone has the right to be happy and feel less wounded. All designers eventually work on behalf of clients and in the service of future users of their buildings. Those clients and future users are human beings who also wrestle with worries, anxieties and, sometimes, with trauma. The twenty-first-century designer is one who has begun to know and learn from the qualities of her own mind and body. I have no doubt that bringing these lessons to the design of the built world will benefit many people.

Standing Up

One evening a student called me at home. He was agitated and right away asked whether it was okay to be calling me to discuss his work. He made it clear that it was not really an academic question that was bothering him. After years of working together, his professor was telling him that his project needed a significant overhaul. He was frustrated; he had been responding to these critiques in good faith for over a year yet never seemed able to escape his teacher's demands that he reshape his project. Because he needed her approval to complete the project, he felt too vulnerable to refuse her constant revisions. He was finding himself doing more and more work. The project was now nearly three hundred pages long. Typically, a project would rarely be much more than one hundred pages. It was a vast and ambitious work and what kept it from being likable was that it was obviously not his work. He had done her version of his project and it was not at all what he had

set out to do. He had sacrificed himself and taken on a bloated agenda potentially driven by his professor's own insecurity.

The tragedy of all of this was that his topic concerned a town overwhelmed by a large-scale infrastructure project. The town had quietly accepted that the investment would bring a world of good, but it had actually delivered very little. I gently suggested that he had repeated the same fate by pleasing the professor, in the process forgetting his own needs and desires, but he did not know how to disentangle himself and assert his voice in his work. I could hear his frustration, and the anger he had both with her and ultimately himself. I, too, was upset. This was a kind of educational theft. The student never stood a chance. What he was experiencing was a betrayal of power and trust. And in the end there was nothing to do except reclaim as much of the work as possible. He needed to put himself and his beliefs back into the document. And this is what we worked on. He renamed the project so it was less abstract and more localized. When he finally presented his work the most memorable moments had nothing to do with the huge amount of research and exotic diagrams, but his personal stories about the chosen place. It was a down-to-earth presentation and through his warm communication he reclaimed his place in the work. About a month later I opened my office door and found a nicely wrapped box on my desk. I did not know how it arrived there, who it was from or what it was, but I put it in my bag and drove home. The next day I opened it and was surprised to see a beautiful hatchet. Still unsure as to who had sent the gift, I read the card. It was from Frank, the student who had called me, and the card said, 'Thanks. Keep cutting through the bullshit.' Staying true to ourselves takes courage. Without knowing ourselves there is nothing to guide us in our deepest creative decision-making. Never underestimate the far-reaching effects of a simple act of courage that begins with staying true to your self.

6

Empathy and Collaboration

IN THE EARLY twentieth century dozens of newly designed buildings were hailed as revolutionary and iconic. Architects imagined buildings that had no ties to the past and belonged to the future that would soon arrive. The appearance and texture of the Western world was forever changed by these radical inventions. Venerated for their avant-garde posture and intellectual commitment to social idealism, these creations inspired a century of architects to experiment with self-expression at the expense of context. So individual and personal were these designs that they could best be introduced by the words, 'This is my design.' By the end of the twentieth century, such an approach was still very popular, but complications had emerged. Suddenly, competing issues and ideas threatened this unbridled individual self-expression; issues such as sustainability and accessibility threatened to put a damper on the seemingly unlimited focus of 'my design'. An uneasy stand-off ensued and gradually those self-important designs reluctantly accepted the burden of including accessibility and sustainability. Although these issues were often perceived as complications or obstacles to design, they would not disappear. Since the last thirty years of the twentieth century, in fact, they have become the law and are increasingly legislated into building codes and practices.

By the twenty-first century, it had become clear that the rules of design had changed forever. Design can no longer mean 'my design', it must now mean 'our design'. Our design includes awareness of and respect for climate change, the extinction of species and habitats, the management of energy and resource use, and the

legitimate needs of every user. Our design includes children and
the elderly, as well as people with specialized accessibility needs.
Looking into the future, perhaps our designs will also include the
alienated, homeless and displaced populations, with room for
those who protest and those who prefer to live online. What might
this mean for the new designer? First, the twentieth century is
over. The century of unparalleled death, scapegoating, exclusion,
trauma and destruction has given birth to the potential for a new
age. Why should we go back when we have the chance to move
forward, to bring a new awareness to the education of designers?
In the twenty-first century every act of design is a global act for or
against the well-being of our planet. Our new intelligence allows
design to spring from a deep and lasting affection for one another,
even for our enemies. The survival of this fragile and vulnerable
planet depends on our willingness to care about it. Glamour has
been a large factor in design culture for many years; now caring
clearly needs to have an opportunity to set the agenda. The longer
life exists on Earth, the more this will be true.

Dinner

AFTER A LONG day of teaching several of us had planned to have
dinner together. We had never spent time as a group outside
of school, so I was curious to see what our social experience
would be like. At first there were the typical jokes and banter
that usually happen when people get to know one another, but
once we were all seated, one fellow seemed to be really keen on
describing to all of us his busy life. He gradually took over the
conversation. It was not that we were particularly curious about
his life, he just had a huge appetite for attention. He began to
describe his constant travels with other busy architects, his life
of catching planes and going to important meetings and eating

at great restaurants and doing great work. The waiter took our orders; the food came; we had more wine; and still he could not stop talking. Occasionally, someone would venture a comment or share an experience, but all roads led back to our VIP. I remember thinking to myself that if I were married to this guy I would find it unbearable. The food was good, but I had mentally checked out and was planning my exit strategy, deciding that I would not stay for dessert or coffee. I could not wait to leave and was discreetly checking my watch.

Finally the main courses were taken away. The table was less busy and I could see that others were also slowly preparing to leave. This had clearly not been about a group sharing a meal and it soon became obvious that everybody was going to leave. We asked for the bill and a few of us started to make our excuses. At this point, our VIP quietly said, 'I never thought that my wife would leave me. I just didn't see it coming.' He missed his young daughter. He had endless stories of airports, meetings and important clients, but he was totally alone. Chasing these dreams had cost him his connection to the ones he cared most about.

Every day we hear about problems. Economic, urban, environmental and political conflicts are constantly in the news. And despite the variety of circumstances, all of these problems are really the same. They are human problems. When we hear about a river being polluted, it is all too easy to lose sight of the fact that pollution is always the direct result of decisions made by human beings. The same is true of all urban problems. The city itself makes no decisions; human beings, often working in groups that function within larger groups, have made every single decision. And many of these decisions rest on years of research and analysis, which brings both good and bad news. The good news is that problems caused by

human beings have the potential to be resolved by human beings. The bad news, as Jung pointed out, is that we know far too little about human beings. It is important to keep in mind that, compared to the material sciences, psychology is a very young field. We are at the beginning of our journey towards understanding humans. We are only about one hundred years into the science of psychology and human behaviour. Freud's discovery of the unconscious was like the discovery of fire. We have just begun to understand ourselves.

What could any of this possibly have to do with the world of design? It means that the education of designers needs to become more modern. Not just technologically modern, but psychologically modern. We must make use of tools that bring awareness to how we learn from the built world, how we learn about design and how we learn from one another. The long-standing bias that values cognitive intelligence over emotional intelligence needs to be factored into all aspects of design, because our mental models directly affect our decision-making skills. No one would explicitly agree to a project that obliterates whole species or habitats, but the great interconnectedness of our planet means that we do this all the time. In the future, a designer's education will include an understanding of how we make creative decisions not only as individuals, but as collaborators.

How can you make wise design decisions without first declaring your honest view of basic human needs? As designers, we are both concerned with and involved in changing the world. We are beginning to understand that our survival rests on consciously becoming wise stewards of the planet. I think of stewardship as an awareness of the deep interdependence that pervades all things. Designers are uniquely positioned to influence because their work occurs at the confluence of so many people, materials and needs.

AS I SIT at my computer looking out of the window, I am very aware that I did not build the house I live in, make the desk I am working on or assemble the computer I am using. I had nothing to do with choosing or installing the windows. They were all designed and built by others, and they rest on years, in some cases thousands of years, of human skill and creativity. Every built thing is the product of a vast and complex chain of know-how and interdependent systems. You may wake up in a bad mood and not want to get out of bed, but keep in mind how much has been done by previous generations so that when you get up there will be drinkable water and electricity. Even the simple cup of coffee that starts your day rests on a vast chain of human beings whose efforts made your latte not only possible, but relatively effortless. We are social animals. We need others from the moment we are born until the moment we die, but we live as though this is not the case. Our progress undermines our ability to recognize our need for others. Sometimes I think that in exchange for being born we are compelled to be optimistic about the future. After all, when we wake up in the morning it is easy to forget that our clean water and reliable electricity exist because of the desire for social betterment that spans many generations of inventors, politicians, scientists and citizens. Our ability to enjoy a world that allows us to focus on design rests on the hard won achievements of those who came before us.

Years ago I tried to teach myself to say grace before eating a meal. For weeks I found myself several mouthfuls into the meal before I could remember my aspiration to say grace. What would our world look like if we designed and lived bearing in mind the reality of our dependence on others? How do we teach this awareness?

Conscious Studio Collaboration

At the start of a third-year design studio, I took an informal survey and asked, 'Who wants to be successful?' Of course, every hand went up. Then I asked, 'Who wants to be successful if it means that the person beside you is also going to be successful?' Again every hand went up. People were happy to share their success. Based on this survey, I set up an exercise. Students would prepare a list of three of their most pressing design problems and prepare all the necessary documentation for the problems to be solved by someone else. A group of four students would work on behalf of their classmates to bring fresh creative energy and insight to the problem. It took a few hours and by the end of the morning everyone had been helped and had helped others.

This approach generated an enormous amount of creativity and goodwill. In every case students were delighted with the new learning that took place and asked for more. There was serious debate and laughter, and a rush of ideas and drawings. The feeling of competition and isolation that can dominate a design studio dissolved and was replaced with a sense of connection and interdependence. What was particularly interesting was the opportunity to watch otherwise shy or reserved students suddenly come alive in collaborative settings. The dialogue also brought out in-depth design debates that had everyone scrambling to supply first-hand experiences to support their points of view. I think of collaborative design as a kind of design accelerator.

I have some basic rules for conscious collaboration:

1 Prepare three clear questions.
2 If you want a philosophical problem solved, ask a philosophical question.
3 For more practical problems, make sure that the problems are as clearly described as possible. Students often realize

that the ones who ask the most direct and thoughtful questions get the most useful feedback.

4 Keep track of the results.

5 The material generated through the collaboration can be freely accepted or rejected.

6 Be prepared to listen.

Beforehand, the teacher should explain to students why they are doing this exercise. My own approach is to point out that there is a lot of talent in the class, and I want it unlocked and shared. I talk about the value of listening and the merits of debate. I remind everyone that we are not opposed to having fights, but that they have to be fair – which means no low blows. I strongly encourage the students to debate and practise building strong arguments for their positions and their suggestions as they answer the questions (the very act of making an argument for design is extremely important). Then, I sit in a corner of the room and keep time. It is important to be in the room to help hold the space of the exercise. I also think it is important for the teacher to not be on a computer. The teacher needs to be seen to be paying attention to the content that is unfolding.

Listening to Design

On the first day of the project, after the assignment has been presented and explained, students form groups of no more than four. One person takes on the role of architect and has ten minutes to describe his or her vision, ideas, thoughts and reflections about the project. The job of the three listeners is to record everything they hear, to especially listen for ideas and descriptions of places and details.

The listeners can ask questions, but only if the architect needs help with the vision. This is to ensure as frictionless an atmosphere as possible. Whatever the student playing the role of architect or chief designer describes will be given back as a completed drawing to use. After ten minutes, the visionary has a package of text, images and drawings to go through, edit and develop. This allows the project to begin with momentum. It also ensures the rapid collection of shared ideas that will spawn many more possibilities. It is true that this approach favours those who are able to clearly articulate their ideas and may put introverts at a disadvantage, but it is also surprising what a little positive time as the centre of attention will do for an introvert.

I like to begin these collaborations with a guided imagery exercise to connect everyone and to open them to the power of collective experience. If, as Jung wrote nearly a century ago, emotions are contagious, so, too, is creativity.

When we teach design, we attempt to simulate real-world conditions, but working alone and talking to a professor is much less like real life than discussion in a room full of colleagues where differences have to be reconciled. Working individually on a project can be isolating and, in the professional context, every project is accomplished by teams of people. Even the most modest project rests on a complex web of multiple relationships. Most

professionals will tell you that a good project not only requires a successful design, but a successful team working together.

The relationship between leadership and cooperation is never discussed in design schools. It is left for the real world, where, unfortunately, it is still rarely discussed. Yet teams of people are required for even the smallest projects to come to fruition and we would be wise to begin to learn and teach the factors that promote harmony and successful cooperation.

Ideas can change and will change as they are discussed, shared and debated. The chemistry of colleagues, shifting interactions and difficult circumstances are inevitable ingredients in the cocktail of cooperative experience. The capacity for an idea to mutate and acquire character and dimensions beyond the starting point of a single person is one of the great joys of design.

Cooperation

ONE AFTERNOON I decided to go to the wood shop to begin a project that I had been planning for some time. It involved building a very long shelf made from Baltic plywood. It was going to span two book shelves and a radiator and I was hoping that the choice of wood would keep the shelf reasonably stable as it faced direct sunlight and sat above a radiator. Although the shelf was simple, I thought of it as a long bridge with many openings; the way it was to be assembled was complex, requiring great accuracy and care of construction. These things are not my strength. Many different-sized pieces of wood had to be cut and precisely fitted before being glued and clamped together.

David was a student who was helping out in the shop that day. He was an experienced woodworker and as I sketched out my plans with him, he took the time to share a few very

practical suggestions on how best to put the project together.
I was glad to receive his advice. His know-how would save
me from making the usual beginner's mistakes that add time
and often undermine the final quality of the work. As the day
wore on he became more curious about the project and offered
to help me. After an initial feeling-out process, our working
together soon became effortless and we quickly developed a
resonance and rapport. 'That puppy fits perfectly.' 'Yup. Snug!'
'Sweet.' Decision-making and fabrication merged into a spirited
accord with all kinds of tasks quickly discussed, debated and
frictionlessly agreed to and acted upon. A job that I had thought
would probably take a week started to come into focus. Cuts,
clamping, gluing and assembling required and received a
synchronized team of hands, and David and I fell into a selfless
rhythm of working together.

At one point David remarked that he felt as though we were
sailing a boat – we were experiencing shared attention focused
on a single goal. Our cooperation became more and more
effortless and energizing and we naturally began to increase our
progress until, in the late afternoon, I realized that there was a
chance we could complete the job that day. I asked David if he
wanted to complete the project and he said he now felt invested
in it and wanted to see it not only completed but done well.
Heartened by the ease of our progress, we raced ahead. When
the final pieces were assembled and clamped we took our first
break in several hours. I thanked David and said that I wanted
to buy him a bottle of wine in appreciation for all of his help.
He thought for a moment and then replied: 'If I accept a gift it
would be as though you were paying me. And if you pay me it
would be as though the day had not been about cooperation.
I prefer that this day be about cooperation.' David explained
that one of the reasons he had returned to school was that he

was looking for something that he had found lacking in the contractors' world: the spirit of cooperation. He wanted to make it the cornerstone of everything he did.

We had completed the project to a very high quality in a single day. The shared energy of the build had been wonderful. Cooperation builds goodwill, which in turn solves obstacles by accessing unanticipated resources and skills. Harmony and goodwill are not some kind of last resort to be summoned only when things have soured and got out of hand. I often wonder what might happen if we spent more time teaching the hidden rules of cooperation and goodwill rather than simply teaching the facts that accompany solving problems. There are many kinds of intelligence waiting to be brought into our reality. The intelligence of cooperation has the potential to bring the wisdom of the heart directly into all kinds of complex problems. While we battle back and forth in our minds to find the right answers and do the right thing, an alternative is to bring the problem into our hearts and let the wisdom energy of compassion illuminate and loosen the tangle.

Sleep

IN TEACHING GUIDED imagery and visualization techniques to postgraduate architectural students, I found that about one-third of the students fell asleep during any exercise. I always used a variety of relaxation protocols so that students could learn which approach suited them best, but this never seemed to affect the number of students who fell asleep. I assumed that they were just exhausted from twenty years of education and that given the chance to relax they would naturally fall asleep. When we discussed the feedback from their experiences, the students who slept sheepishly reported that after falling

asleep, they woke up just in time to hear the suggestion 'begin to write out your experience . . . '.

Falling asleep is understandable for students because constant mental work is just as exhausting as physical work. Sleep also tells us the body is being allowed to have an authentic experience, which is good news. After all, not being able to sleep when you are tired is a far more troubling experience. After falling asleep during guided imagery work, one student asked for some suggestions. He said that he really wanted to experience the exercises and did not want to be missing out by sleeping through them. I suggested that he begin by taking a few moments before the next exercise to dedicate to others any positive energy that he might acquire during the exercise. For example, 'May any positive energy, positive emotions, lessons or insights that might arise during this experience be shared with all human beings.' Serving others is almost always refreshing, but never more so than after a period when you have been working on your own. Rather then doing a guided imagery exercise for his own benefit, he was willing to share his positive states with others. After consciously adjusting his intentions, he stopped falling asleep.

Whenever the topic of sleep comes up I find that students have a great deal to say, and it is clear that sleep is a vastly underappreciated activity. It is a basic ingredient of health, but beyond the number of hours of rest we need, it is also an opportunity to trust your body and trust what it may need to feel healthy. Less discussed is the idea that sleep might also be useful as a creative experience. For example, it is a time for dreaming. And because the dream is not the work of the ego but presents a snapshot from the point of view of the unconscious, it has much to tell us about our relationships both inwardly and outwardly. I find that dreams constantly support a creative life.

In a way both creativity and dreaming share a common trait; they are not controlled or occasioned by the ego.

But even if you do not remember your dreams there is another important experience that accompanies sleep: the chance to use the shadowy time just before falling asleep or the moments just upon waking to play with ideas and subtle thoughts. These twilight states when the ego is less vigilant, and we temporarily have a foot in both the conscious and unconscious mind, can bring a special vitality to all sorts of creative explorations. Letting the imagination effortlessly sift through possibilities seems to reset the mind and body and prepares us for our next task. A simple experiment I would like to suggest involves one group of students taking a nap after lunch while the other group works through the day without a nap. How does the nap affect their creativity and experiences of learning?

A friend of mine who was a very experienced scuba diver used to describe his frequent afternoon nap as a 'drift dive'. During a drift dive you surrender to the ocean and allow the currents to do all the work. It is relaxing and refreshing and your explorations feel effortless. Try letting your creative mind surf through possibilities.

If you ask anyone what makes the modern world modern, they will mostly talk about the explosion of information, the shrinking of distances, the warp speed at which everything seems to happen. Who can argue with any of this? These qualities without doubt give our world its modern appearance and texture. If we take a step back, however, we can see that this is just the surface of the world. Technology has always been involved in the process of making our world new, yet just beneath this perpetual modern layer you

will find another world, a darker and less-visited one that weighs nothing, cannot be emailed or thrown away, and, while it often emerges as the driver of our choices, can just as easily defy our wishes. It can separate us from one another or liberate us and we are entangled in it from the moment we are born until the moment we die. This is the psychological world. In this world, the most powerful thing is the way we think about ourselves and others. It affects the life of an individual so profoundly that its collective force can doom or transform democracies or oligarchies. At the same time, although psychology always promises a more meaningful, authentic and fulfilled life, it never promises that the process of getting there will be easy. Opening oneself to the psychological point of view often guarantees a voyage that will be as challenging and intense as a solo ocean crossing. The power of psychology is easy to ignore because a psychological truth never sits on the surface of our lives. It works from inside like a rhizome and is always absorbed into our experience, where it seems to disappear into the flow of constant use.

Cleaning

ALTHOUGH THE THIRTY of us had spent ten days together, we did not know a thing about one another. We had been sitting, walking and eating together, but we were complete strangers. A vow of silence meant that none of us had spoken a word for ten days. Nonetheless a kind of intimacy settled over us. Our meditation retreat was being led by a Buddhist teacher from Burma. I loved the silence and found the strict regime of monastic life very comfortable and relaxing. Inwardly I had been experiencing heaven and hell and assumed that this was the same for everyone else, although I have no way of knowing if this was true. My opinions of others were based on covertly

observing their facial expressions. Some days people looked like hags or pirates and a few days later they looked bright-eyed and full of life. When I had looked in the mirror halfway through the retreat I did not recognize my own face. As the retreat came to a close, the abbot announced that we would be coming out of retreat after breakfast the next day and said that there was a tradition that each group of meditators would leave the place as clean and tidy as it had been found. Our retreat was formally dissolved the following morning and without anyone having to take control, organize, threaten, dictate, coordinate or give instructions, a spiritual community sprang into life. People fanned out in every direction and began to clean the place. No one hesitated to join in and no one rushed. What amazed me was that the most difficult jobs were the most popular. There were extra people working to clean the grease off the back of the old kitchen stove. The bathroom and toilets were scrubbed to a bright shine. People were happily on their knees washing the old floors. There was an outpouring of goodwill the likes of which I had never seen. If I had not been part of it I would not have believed it. It was as though people had been waiting their whole lives for the opportunity to clean toilets and kitchen sinks. The positive energy was infectious and by late afternoon the place was radiant. Everyone had contributed, there had been no grumbling and no one angled for the easy jobs. Although we were all free to talk, we did not say much. Everyone was friendly and helpful and the simple honest work prepared our hearts and minds for the return to our busy lives.

This spontaneous cleaning of the retreat centre was the greatest demonstration of communal goodness I had ever seen. More than anything, it convinced me of the value of mindfulness meditation. For ten days, we had all

been practising non-judgemental awareness. We did this by watching the arising and passing away of phenomena. We began with the basic practice of observing the inhalation and exhalation of our breathing and eventually applied this non-judgemental awareness to every sensation, emotion and thought. At the end of our practice, we were instructed to share anything positive that we may have accumulated with every living thing in the universe. What would be the purpose of bringing mindfulness training into schools where architecture is taught? To lift the quality of design work? To improve the level of cooperation and collaboration at every level of the institution? Could it even bring a deeper sense of empathy and interdependence to every relationship? My answer is yes, yes and yes.

My approach would be to teach mindfulness as a standalone course the way schools currently teach courses on how to use design software like Photoshop or Revit. The difference is that mindfulness is useful for everything, while Photoshop or Revit can only help with certain jobs. Once the basics of mindfulness had been taught, there would be regular classes to renew individual practice and to reflect on the way mindfulness affects learning. Once you are taught to read, the expectation is that you will continue to read. The same is true for mindfulness. Students would be encouraged to make time for individual and group practice. Faculty would of course be expected to lead the way with their own mindfulness practice. A space in every school would be set aside for and dedicated to this purpose. We have a gym for the body. We have a library for the intellect. We have a studio for creative life. Now we need a space for developing empathy and interdependence. This is not meant to be a quick fix for design and architectural education or the built world, but rather a long-term commitment to

transform the relationship between human beings, problem-solving processes and design. It has the potential to give to the individual what ancient public space gives to a city: a timeless and shared place of becoming.

7

Presenting and Persuading

DURING MY FIRST three years as an architecture student, I sat
in the lecture theatre all day listening to different architects
talk about their work. The range of speakers and topics was
incredible. Some were the greatest architects of their day while
others were less well known, but I didn't care. I was like a
sponge and I relished the opportunity to learn from so many
practitioners. I also had a chance to hear historians, cultural
theorists and artists, and I quickly came to realize that the
lecture theatre and library were two of the greatest resources
at the school. When word spread that a well-known architect
would be speaking there, you could feel the excitement rise
throughout the day. Seats would begin to fill well before the
presentation as local architects converged on the lecture
theatre to compete with students for vacant seats. A celebrated
architect would receive a rousing introduction that always left
me truly impressed and inspired.

The speaker usually began his talk by saying something
like, 'Hello everyone. It's a pleasure to be here. Today I would
like to speak about some recent work. I am going to talk about
our recently completed National Communications Centre
and then I'd like to show our new condominium tower in
Dubai. I also want to show the work we have been doing in
Malaysia on their new transit system and I'll finish with a
brand-new university campus we have just been chosen to
design in Tashkent. Actually we just heard about the results
of the competition yesterday.' What would follow would be an
amazing gallop through the world of ideas, places and cultures.

The finished buildings and drawings were dazzling. Afterwards, everyone gathered in the bar, where brilliant rhetoric dissected the relative merits of the event. Sometimes it felt as though the room was going to combust or collapse with the intensity of opinions.

Years later, when I studied psychology, there were no university-sponsored lecture series, but I found a nearby teaching hospital that held a lunchtime lecture programme. I had never heard of any of the speakers but the topics all sounded interesting, so I decided to attend one of them. I arrived early and found a good seat. The surprisingly well-attended lecture took place in a small auditorium. The brief introduction of the speaker revealed that he had graduated from a local university and had been working in his area of expertise for fifteen years. After polite applause, the speaker stepped onto the podium, thanked everyone for coming, then began. 'My name is Dr Bill Harris and I would like to talk about alcohol addiction. My grandfather was an alcoholic. My father also drank heavily and died of causes that stemmed from his addiction. I have been sober for sixteen years and I would like to speak about some of the challenges of treating intergenerational addictions.' The man on the stage was not suggesting that he had necessarily accomplished very much in his life. He was as comfortable sharing truths from his life experience as he was sharing clinical practices. But as he spoke, he seemed very secure in himself and showed no fear or shame. I admired his courage and humility and settled into my chair, feeling very inexperienced and naive.

Dr Harris's talk clearly illustrated that while worldly achievement is important, whatever authority he had as a human being came from his life experience and from helping others. Over the next two years, I had the opportunity to watch many presentations in the field of psychology and the best ones all shared

this genuine quality of service and a compassionate attitude. A genuine sense of self is the most powerful thing one can bring to a presentation. People are interested in reality. If the person in front of them is telling a truth we are immediately interested. Perhaps we are tired of impersonal information.

Final Review

Every design studio climaxes with a final review. When I was a student, these could be emotionally abusive affairs in which the invited guests often extravagantly criticized everyone to the point of cruelty. Self-centredness and arrogance were on full display. It was never a fair fight; the students did not stand a chance. Some were in tears as their projects were ripped apart. It was as though they were not even in the room. Exhausted and drained of confidence, students stood in front of their peers in a rite of passage that had more in common with hazing rituals than educational ones. These reviews were terrifying and even the anticipation of them added a very real level of anxiety and stress to the term. Mercifully, these days are passing. Today I know of many architects who can barely discuss their experiences because of the shaming and humiliation they suffered while learning to become a designer.

I am not suggesting to the critic that every project has to be praised. On the contrary, one has an obligation to use the desk crit to teach important lessons about architecture, the design process and the dynamics of the presentation. But one also has an obligation to communicate in a way that is respectful and promotes learning.

To the student I am saying: take the opportunity, as soon as possible, to learn about your strengths and weaknesses as a communicator. Some people are born to talk about their work. They appear fearless and actually enjoy standing in front of strangers

explaining themselves, even when their projects are not that interesting. For the rest of us, practice is necessary.

AS A STUDENT I usually loved what I had created and presenting it was something I looked forward to. I was always very nervous and excited, and there was never enough time to prepare the actual presentation. When my turn came, I would stand up and present everything that seemed important. If you asked me after my presentation what I had said, I would not have been able to tell you. The mood of creative inspiration mixed with nervousness and desire for everyone to love what I had done made it impossible to know what I was doing.

I once taught a small postgraduate class of students who, even though they were all very creative, were very shy and awkward when faced with the requirement that they present their work.As I listened to their presentations, which included body language that often defeated what they were trying to communicate, I decided to try an experiment. I asked if they would allow me to record their next studio presentations. Everyone agreed, so I did just that. At the end of the day I handed everyone a DVD of themselves presenting their work. The following class I asked if anyone wanted to talk about what they had seen. After an uncomfortable silence and some squirming, everyone decided that they wanted to keep their experiences to themselves. I knew that what they had seen had made a significant impression because our next round of reviews was really impressive. The majority of students had improved their body language and voices, and their powers of communication continued to improve throughout the term. I also saw students giving one another feedback on their presentations that indicated the once frozen and frightening task was now a place of growth.

Not everyone is comfortable in the spotlight. Some people prefer to be on the sidelines. If your school or university does not teach the fundamentals of how to communicate and present your work, you should immediately sign up for help. Try Toastmasters, a worldwide non-profit that assists people in learning to speak publicly. Another helpful option is to find a voice coach. If your school or university has a drama or theatre department you can find help there.

When I started teaching I was frustrated with my inability to communicate what I was thinking and feeling. I had been invited to give a presentation at a conference and realized that I needed some help. I went to see a voice coach who had come highly recommended by a friend who wanted to become a better singer. I was unsure what to expect. I explained that I was not a singer as soon as we sat down, but she just laughed and said that was not a problem. Then she asked me what I wanted to work on and I explained my struggle with public speaking and was immediately struck by her total focus. Her powers of listening were extraordinary, almost unsettling. She asked me to read some poetry, and I realized that I had no idea that emotions were supposed to accompany the words of a poem. I went to see her several times and while her voice-coaching skills were great, for me it was her capacity as a listener that stood out more. I was still nervous when I had to present, but with practice I began to find my way. Over the next year I grew into my voice and into what I wanted to say. My confidence came as much from practising as from believing that I had the right to speak.

A final architectural design presentation is a big deal. It is something you will get hundreds of opportunities to practise over the course of your education in design. You want to present your material in such a way that the audience is constantly in delight in their understanding of your work and your audience experiences a clear 'Yes!' inside themselves as you communicate your presentation. You want to deliver your ideas, drawings and models so that they are all in service of your big idea and they all play a role in expressing the idea in the best possible way. Information does not have to be repeated; the information conveyed by the plans does not need to be restated in another drawing. Everything needs to work together. Think of your presentation as a team of drawings and models. Each one performs a specific role in conveying your ideas, in much the same way that, in a game of football, a forward, defender or goalkeeper might contribute towards a winning goal.

This may all sound logical but it is extremely challenging in an environment of sleep deprivation, plummeting confidence and creative uncertainty. Not to mention being afraid of public speaking and the reaction of critics. The sum of the parts is a complex environment, one in which control is hard to find. Yet this is exactly what the presentation asks of us: to be in control of what we are trying to communicate.

The purpose of the presentation is to clearly convey the intentions and ambitions of your project. The best way to do this is to generate a convincing argument that is completely supported by your drawings and models. It is necessary to build a compelling storyline that explains what has been driving your work and is really an elaboration of your big idea so that you bring your audience into an understanding of your work.

The key to being successful is practising what you want to say. If you say that your project is about fitting into the site and the drawing shows a project that does not do this, the critic will either

be confused or say 'No.' Soon they will begin to argue with you. When your review panel responds to your presentation with a 'Yes' they will begin to move in the same direction as you. They will be influenced by the work and they will generously amplify all its virtues. You will enjoy a very positive learning experience.

If possible, ask a friend to record your rehearsal and then watch yourself presenting your work. Begin by writing out the key points, which should be supported by the drawings on the wall and the models that accompany the presentation.

You are not trying to be argumentative; you are making an argument for your proposal. This is one of the most important things to learn as a student, because for the rest of your professional life you are going to have to become a master communicator. Your ability to present your graphic skills needs to align with your verbal skills. If you say one thing but show something else, you are going to create the impression that you are not in control of what you are doing. This will usually lead to the presentation concluding in a very negative way.

I had one student who was clearly upset when she sat down to discuss her project. Her professor had told her that her work was complete, but she did not agree. She wanted to take out long theoretical passages of text and replace them with her more poetic and subjective point of view. She felt that in its current form the thesis did not express her voice; it expressed the voice of her professor. Her professor, however, opposed the changes she wanted to make. In the end, she took a courageous stand and defied him. She made the changes to her presentation that gave her back control of her work. Sadly, she suffered through public criticism when the professor told her that he was disappointed by the lack of theory in her work. He was clearly upset because his advice had been ignored. When I spoke to her afterwards, she told me the criticism did not bother her at all – she was expecting it. She knew that she did not want any more theory in her work, she wanted more soul. She had tried to explain this to her teacher, but he thought that she was not being serious about her work. She had been willing to pay a price, but she was confident about her final presentation.

Another student found herself frustrated because whenever she wanted to discuss her work she felt uncertain about what she wanted to say. She felt trapped by her inability to express her ideas. In fact, she heard increasingly negative statements in her head whenever she tried to explain herself. She felt as if she could only speak for a few seconds before she lost her confidence and creative energy.

I suggested that she approach this the way athletes or musicians do when they want to improve their performance. They practise. And the practising often involves a coach or mentor who is putting positive energy into their work-out

or rehearsal and giving very detailed feedback. Athletes or musicians use this to learn not only about their craft, but about themselves. I thought that it might help if she wrote out what she wanted to say, but to pretend that she was expressing her ideas to a best friend or adoring grandparent. I told her to imagine that her listener is encouraging, attentive and supportive. Take all the time you need, I said. Don't rush. Give them every detail. And don't edit. Just write. As you begin to build up your story, pay close attention to the energy you feel in your body as your ideas begin to flow. See what brings momentum and power and what causes you to lose focus. Be fiercely loyal to your creative voice. Eventually the student decided to take a public-speaking course and told me that she was thrilled to discover how much she enjoyed it. She won an award for her final presentation and this gave her the confidence to tackle another long-repressed desire: learning to kickbox. Again she was surprised to learn that she had untapped abilities and really enjoyed the classes. In the course of a year I saw her shift from shy and uncertain to confidently assertive and energetic. Our meetings were longer and she not only had more to say about her work but questioned her decisions more usefully.

Be familiar with what you are being asked to do, but do not overanalyse the requirements. Instead, focus on what it is you want to say. What is your project about? What is it like to be at the site? What is it like when the weather is unpleasant? How is the place to be enjoyed and occupied? What is it made of? What is it like to approach and be inside it? When in doubt, let the drawings communicate something that cannot easily be said, such as the character and soul of the place.

Use the requirements of the assignment to express your big idea. Too often I see the requirements driving the presentation. They need to be included among the ingredients, but what you choose to cook and how it will taste is up to you. The first minute of your presentation is very important. Like the trailer for a film, it needs to declare the atmosphere, insight and key characters in your story.

I ONCE HAD a student who was trying to decide how best to draw her final project. She showed me several images that she had produced but none of them seemed very convincing to her and she did not know what was missing. I asked her what had inspired her first response to the site and she started to talk about the grandeur of the place. Her project was near a mountain and the night sky was often filled with the aurora borealis. Articulating that made her suddenly realize what her drawings were missing. The images showed the building she had designed but completely left out the magnificence of the site. I suggested that she make her building much smaller and let the grandeur get bigger. She took a moment to think about that, then turned to me and said, 'Okay. I know what I need to do.' A few days later she asked to meet with me again. Her building was now much smaller and the mountain and the brilliant night sky dominated the image. It was a sublime presentation rendering that really captured the

place, although now she was worried that the building she had designed looked too small. I pointed out that her elevations clearly showed her design work and she felt better.

Put it to the Test

Many millennia ago, the Buddha, in the Kalama Sutta, made the following declaration, which I have always thought was a beautiful way to gauge if something rings true:

Not because you hear it repeatedly
Not because it is the tradition
Not because it is a rumour
Not because it has a long history
Not because others think this way
Not because it is philosophically argued
Not because it is called common sense
Not because it agrees with our own opinion
Not because it is a belief of our teacher's.

Only when you have independently tested and observed that these things lead to benefit and happiness, should you accept these things as true and incorporate them into your work. Always welcome careful investigation.

WHEN I HAD the chance to offer a postgraduate course module based on my book *The Inner Studio*, I was worried that students would not be interested. The class description was sent out and ten students signed up. I only needed eight to run the course, so away we went. Every year I learned more about how to present psychological insights and experiential exercises to

architecture students. Every year I made changes. And every year students continued to show interest. The first few years were overwhelming. I questioned whether a school of architecture was the right setting for the material in which I was interested. I felt that we needed to make buildings and places that spoke to all human beings and I believed that the best way to do this was to take a psychological approach. But I struggled to strike a balance between the architectural and the psychological.

A casual conversation with my doctor gave me an important clue. He had a wonderful bedside manner and I always felt reassured when we spoke. He mentioned that he had been asked by the university to teach a class focused on humanizing the relationship between doctors and patients. It made perfect sense that the university had chosen him to lead the class given his disposition and I asked him how it was going. He said that the first year he had tried teaching the five thousand facts and he had hated the experience. In fact, he thought that it had been a complete disaster. So the next year he brought in a social worker and it was fantastic. They role-played every situation that a year earlier he had tried to simply teach. That conversation convinced me to reduce the amount of information I was trying to pass along and increase the experiential side of the classes. My training as a psychotherapist led me to use guided imagery exercises to take students into deeper and more subtle creative experiences, free of deadlines or acquired habits. In order to ground everyone, I asked that experiences be written out and drawn. Students formed small groups in which they took turns listening to one another. The guided imagery formed the basis for an exercise in the power of non-judgemental listening. We discussed at length the importance and challenges of listening. The students did not share their guided imagery exercises with me. I checked to make sure that students were having a positive experience, but the information

was kept private. Most of our conversation and feedback focused on listening.

What happened in these deeper experiences of listening? What role did listening play in making one's own creative decisions? I was surprised by the students' interest in visualization and guided imagery. I was able to get the architectural library to purchase many books that we then used. People started to share more of the challenges of their design process. After ten years of teaching these skills to postgraduate students I felt confident enough to begin bringing some of these lessons to undergraduate courses. The guided imagery was used with design studio exercises. Listening skills complemented the guided imagery exercises. My goal was to give the studio design resources that had their origins in psychological experience. I increased the amount of collaborative and co-creative work between students so that the gift of creativity was constantly being shared. The quality of the work improved, as did the joy of teaching.

Picture

In the crazy rush to complete a project, we sometimes forget that the purpose of the drawings is to tell the story of the big idea. And every drawing has a particular role to play. I think of presentations as a special kind of theatre, in which each drawing is a character helping to tell the story. The audience needs to be introduced and taken through the narrative of the project. The narrative is the argument for the architecture. It must analyse conditions and define the job to be done and the ways in which architecture can accomplish this.

On one level, drawings are conventions. They have been used for many years to communicate the intentions of the architect. The

information conveyed by the plan is very different from that contained in a section. The plan is influenced by context or by what information we choose to include. Of all the drawings, it is the vignettes, or perspective drawings, that are the least circumscribed and most purely tasked with telling a story. The image has the potential to both tell a story and show the promise of the place to be experienced – how we want it to be understood. In every case, the style of drawing and the use of particular drawings seem to me a way of understanding the degree to which a student is in control of what they are trying to say. What am I trying to say? What is the most elegant, direct, persuasive way of communicating what I want to say? These are vital questions to reflect on and consciously answer.

In Japanese woodblock prints, communication is elevated to its highest genius. Hiroshige's eighteenth-century images of a village in winter are not just scenes of winter, as the titles suggest, but images that communicate the silence, temperature and atmosphere of winter. In particular, the few footprints in the freshly fallen snow tell us also about time. The picture represents precisely that moment when snow has stopped falling and the first steps have been recorded. What began as a simple image of a village in winter becomes an all-sensory experience. And when that happens, our imaginations are activated. Now we are making the story our own by remembering experiences or becoming curious. This is the power of imagination when the senses are involved.

Successive generations of artists expanded on these accomplishments and their winter scenes show even deeper silence and more discerning qualities of time, solitude and the season. It is not by accident that a mood of transience permeates these images. The same skills are at play in iconic scenes of Mount Fuji. The greatest thing about these images is the way the mountain is contrasted against the large breaking wave. The most permanent

thing is held beside the most impermanent as if to briefly suggest that even the greatest and most fixed things are subject to change. All of this from a simple scene of the mountain from a fishing boat and a concept that rests on Buddhist principles of impermanence.

My favourite scenes from contemporary printmakers take the view of a gate or doorway and skilfully reduce the visibility, the space where our eyes and mind wants to travel. Steps, gates and doors are artfully obscured, causing us to question, or at least become aware of, our desires. Partially obscuring the goal arouses imagination and intensifies imagination. Time, desire and travel are all summoned. We want to move through the gate, but our mind and body need to first agree to surmount the obstacles. Suddenly the flowering branch that was merely in our way becomes important and we are shifted into a more body-centred experience of observation. Scenes of rainfall on a bridge coupled with dark skies and blowing wind communicate not only a bleak and cold rain at dusk but a desire to hurry and get home. We are not only saying that we feel empathy for those crossing the bridge. The drama is not whether they will make it across, but the question of how long they will have to suffer. In every case, the pictures, which seem simple enough on the surface, also carry an inner dynamic, a psychological dimension that offers unexpected relationships. These images and their evolving traditions give us glimpses into what final drawings can be. They involve the audience because, like all of the best stories, they call for participation by the audience.

Too often an architectural drawing merely fulfils a requirement and fails to fulfil the opportunity to tell a story. I have seen really compelling architectural images that argue so elegantly for a particular point of view that they become the defining moment of the presentation and are long remembered for their wise and effective storytelling power.

Presentation

Throughout the term, one student stood out for his unique vision of a very eccentric project full of personal appetites and obsessions. Although there were many fine projects in the class, his stood out for its original approach. It looked as though it could have been built a century ago or might belong in some future world that had lost its way. The student was always open to instruction and feedback, and everyone who spoke to him at desk crits was thrilled by his work and by his approach. We also felt that he really needed to follow through and develop the project convincingly. No one wanted him to end up with a caricature or cartoon. In spite of the difficulties we knew that he would encounter, he was repeatedly encouraged to follow his vision. Over time his work simultaneously grew more wild and more strangely convincing. We all agreed the project deserved recognition because it embodied determination, discipline and imagination.

Sometimes this kind of project will incur the wrath of critics because it is so personal and outside the conventions of popular architecture. It would be easy to come up with reasons to dismantle and dismiss his proposal, yet he had navigated

all the difficulties he faced and brought it through to a highly resolved state. It was obviously the kind of building that would need an eccentric and wealthy client, but that happens more often than you might think, so we decided that the project should be the last one presented on the final day of reviews. This slot is usually reserved for the best projects of the term. The designers are usually well-known and their work has typically been recognized over the course of their education.

All students attend the final review because they have already presented, so these exemplary projects bring everyone together to finish the term in a resounding way. I want to let everyone know that we appreciate not only the obviously gifted practitioners, but those who bring courage, discipline and unique imagination to their work. We want to send graduating students the message that imperfection is not grounds for being dismissed or disqualified. At this particular review, at the appointed hour the presentation was beautifully delivered to a packed and appreciative audience. This student's work sparked a spontaneous debate from many quarters that brought serious and humorous issues to light. It was a graceful presentation and it defined the studio. Never be afraid to tell a great story.

I FIRST HEARD about the Architectural Association when I was
a teenager reading a book called *City Sense* (1965) by Theo Cosby.
On the back cover it said that the author taught at the AA and
I immediately thought that it sounded like the perfect place to
go to school. I'm not sure why. It was in London, which appealed
to me, but I had the strongest sense that a great adventure was
about to unfold. When I told my parents that I wanted to study
architecture in London they did not seem too concerned. They
were probably relieved that their son was motivated to take
on any challenge at all. I had barely survived high school and
outside of drawing and making things I had no other interests.
I sent the school a portfolio that consisted of drawings and
photographs of a fibreglass toboggan that I had designed and
built at school. It was inspired by my love of Colin Chapman
and Formula One cars. Many years later I visited the school
workshop and was delighted to find that the mould for the
toboggan was still being used by students.

I also submitted large photographs and detailed drawings
that analysed the design of my bedroom, which included as
much furniture as possible hanging from the ceiling. A few
months later I received a letter of acceptance that was dependent
upon my graduating from high school. I was eighteen, hungry
for a creative life and blissfully ignorant of what lay ahead.
I happily counted down the months until I could leave for
London. My mother later told me that she thought I was too
young to live that far from home, but my father, who was less
emotionally involved, simply told me to find someone in Toronto
who knew something about the AA and make sure the place was
right for me.

A few days later I knocked on the door of a small shopfront
architectural office. The secretary listened to me and then
called her husband to the front of the office. I told him that

I was going to be studying architecture in London at the
AA and asked if he knew anything about it. He answered
with a big grin. As luck would have it, he was from England
and he knew all about the place. Incredibly, he had been a
student there. He congratulated me but then quickly added
that the school had recently been a victim of government
cutbacks and had lost its eligibility to receive grant funding
for its UK students. He expected that the school was probably
bankrupt or on the verge of financial collapse. He thought
that it would likely even have to close its doors very soon.
I pretended to not be concerned. He smiled the thin English
smile of grim news, shook my hand and went back to his work.
I thanked the secretary and stepped back into the city. It was
late spring and as I walked to school I reasoned that because
I had a letter of acceptance the place could not possibly be
closing down. Privately I did wonder if some joke was being
played out, but decided that it would be best to say nothing
about this to anyone. A few weeks later, at the dinner table,
I was surprised when my father asked, 'Andrew, have you
found out anything yet about that architecture school you
want to go to?' I slowly put my fork down, looked my father
in the eye and said, 'Yes, I have. I spoke to an architect who
knew all about the place and he said it was a really fantastic
school.' That seemed to do the trick. My father said nothing
and went back to eating his dinner. There'll be no turning
back now, I told myself.

Further Reading

1 Design as Therapy

Davidson, Richard J., 'Transform Your Mind, Change Your Brain',
 www.youtube.com, accessed 1 September 2015
Hollis, James, *Under Saturn's Shadow: The Wounding and Healing of Men*
 (Toronto, 1994)
Pinkola, Clarissa, *Women Who Run With the Wolves: Myths and Stories
 of the Wild Woman Archetype* (New York, 1992)
Richo, David, *How to Be an Adult: A Handbook on Psychological and
 Spiritual Integration* (New York, 1991)

2 Listening and Receiving

Ekman, Paul, *Emotional Awareness: Overcoming the Obstacles to
 Psychological Balance and Compassion: A Conversation Between the
 Dalai Lama and Paul Ekman* (New York, 2008)
Fehmi, Les, and Jim Robbins, *The Open-focus Brain: Harnessing the Power
 of Attention to Heal Mind and Body* (Boston, MA, 2007)
Ricard, Matthieu, *The Art of Meditation* (London, 2011)
Rossman, Martin L., *Guided Imagery for Self-healing: An Essential Resource
 for Anyone Seeking Wellness*, 2nd edn (Tiburon, CA, 2000)

3 Storytelling and the Big Idea

Campbell, Joseph, *The Hero With a Thousand Faces* (New York, 1949)
Catmull, E., and A. Wallace, *Creativity, Inc.: Overcoming the
 Unseen Forces that Stand in the Way of True Inspiration*
 (New York, 2014)

Kimmerer, Robin, *Braiding Sweetgrass: Indigenous Wisdom, Scientific Knowledge and the Teaching of Plants* (Minneapolis, MN, 2013)

Nagai, Takashi, *Bells of Nagasaki* (Tokyo and New York, 1994)

4 Learning from Design

Franz, Marie-Louise von, and James Hillman, *Lectures on Jung's Typology: The Inferior Function; The Feeling Function* (Dallas, TX, 1971)

Goleman, Daniel, *Destructive Emotions: How Can We Overcome Them? A Scientific Dialogue with the Dalai Lama* (New York, 2003)

Johnson, Robert A., *Owning Your Own Shadow: Understanding the Dark Side of the Psyche* (San Francisco, CA, 1991)

Kahane, Adam, 'Power and Love: A Theory and Practice of Social Change', www.youtube.com, accessed 1 September 2015

5 Getting Stuck

Campbell, Joseph, *The Hero With a Thousand Faces* (New York, 1949)

Kahane, Adam, *Solving Tough Problems: An Open Way of Talking, Listening, and Creating New Realities* (San Francisco, CA, 2007)

Lamont, Anne, *Bird by Bird: Some Instructions on Writing and Life* (New York, 1994)

Sanford, John A., *The Man Who Wrestled with God* (New York, 1987)

6 Empathy and Collaboration

Children Full of Life, dir. Noboru Kaetsu (2003), available at www.youtube.com, accessed 1 September 2015

Ricard, Matthieu, *Altruism* (Boston, MA, 2016)

Senge, Peter, 'Systems Thinking for a Better World', www.youtube.com, accessed 1 September 2015

Waal, Frans de, *The Age of Empathy: Nature's Lessons for a Kinder Society* (New York, 2009)

7 Presenting and Persuading

Campbell, Joseph, and M. J. Abadie, *The Mythic Image* (Princeton, NJ, 1974)

Crawford, Matthew, *Shop Class as Soulcraft: An Inquiry Into the Value of Work* (New York, 2010)

Ericsson, K. Anders, and R. Pool, *Peak: Secrets from the New Science Expertise* (New York, 2016)

Taylor, Jill Bolte, 'My Stroke of Insight', www.ted.com, accessed 27 July 2017

Acknowledgements

The idea for this book arrived without warning and was immediately supported by positive circumstances and energy. Andrea Knight was again an expert editor who helped make the writing process both satisfying and meaningful. Thanks to Vivian Constantinopoulos at Reaktion Books for trusting her instincts and accepting this book for publication. For many years I've been fortunate to meet with remarkable students whose creativity and resilience have been a constant source of inspiration and hope. Friends and colleagues made countless contributions to my understanding of the creative process and helped move this book forward. My lifelong journey as a student introduced me to wonderful teachers and healers. Their lessons of patience, kindness and insight planted the seeds from which many of these stories grew. I was introduced to listening by Wendy Golden Levitt whose love made this book possible.